POSTCARD HISTORY SERIES

Main Street, North Dakota

IN VINTAGE POSTCARDS

POSTCARD HISTORY SERIES

Main Street, North Dakota

IN VINTAGE POSTCARDS

Geneva Roth Olstad

ARCADIA

Published by Arcadia Publishing,
an imprint of Tempus Publishing, Inc.
3047 N. Lincoln Avenue, Suite 410
Chicago, IL 60657

Printed in Great Britain.

Library of Congress Catalog Card Number: 00-104307

For all general information contact Arcadia Publishing at:
Telephone 773-549-7002
Fax 773-549-7190
E-Mail sales@arcadiapublishing.com

For customer service and orders:
Toll-Free 1-888-313-2665

Visit us on the internet at http://www.arcadiaimages.com

DEDICATION

*This book is dedicated to my parents, Edward (1912–1976) and Lydia (1912–1998)
Roth, who farmed near Danzig, North Dakota.*

CONTENTS

ACKNOWLEDGMENTS

I would like to thank my husband, Dennis, and son, Terry, for their encouragement and support while working on this book. In addition, I would like to express my gratitude to Dr. Leo LaChance, Evelyn Karppinen, and Jim and Ann Marie Schutz for their helpful guidance through this process.

INTRODUCTION

This book will not be an exhaustive study of the history of North Dakota, as there are many books available about that subject at your local library. Rather, it will be a pictorial history of some of the towns that make up the state of North Dakota.

The railroad played an important part in the development of the state, as many towns were founded as a necessary means to stock building supplies and material needed for everyday life. Many town sites were formed at the end of a railroad, while others packed up and moved the town's buildings to be near the railroad. Although agriculture played the most significant part in the development of North Dakota, there was also mining and the manufacturing of clay products. These industries needed supplies, and the railroad was crucial to the growth of these businesses.

With the development of towns came the schools, churches, banks, and other businesses that were necessary for the growth of the community. Many of the towns found in this collection grew and continue growing today. Others have disappeared from the map.

The success and failure of these towns hinged on several factors. The dust storms, grasshoppers, and the Depression of the 1930s drove many farmers into bankruptcy, which in turn left local businesses with their own financial catastrophes. As the banks closed, one business after another locked its doors and sent its employees off to search for new employment—often forcing them to leave town. However, it was not only these catastrophic events that drove towns to extinction—everyday events contributed also. The rise of the automobile brought the construction of new, modern highways that often left a town isolated. People began heading to the larger towns to conduct their business, and the smaller towns just could not compete. The first one hundred years of statehood have seen the demise of many towns—one can only hope that in North Dakota's next century, history will not repeat itself.

The descriptive text I have included in this collection, with the exception of the postcard messages, is taken from various Jubilee and Centennial books gathered and written by town, city, or county historical societies. We are very fortunate to have such a great organization as the Historical Society of North Dakota to preserve our history for future generations. I have tried to be selective with the text, capturing various facts or interesting information about each image and each town. For more information on these towns, visit the North Dakota Resource Room at North Dakota State University in Fargo, or the State Historical Society in Bismarck. This book is but a beginning—a taste of the history of these towns.

The towns in this collection are listed alphabetically, with the counties following (in parentheses). The population of the town, according to the 1990 Census, follows the text (in parentheses). The date of the card, if known, follows the population.

One
ADAMS TO CROSBY

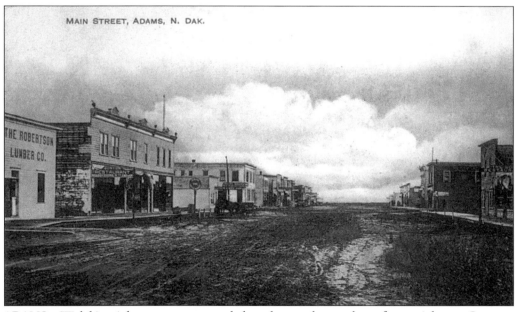

MAIN STREET, ADAMS, N. DAK.

ADAMS (Walsh). Adams was named by the early settlers from Adams County, Wisconsin, which was named for John Quincy Adams, 6th president of the United States. In 1905, the Soo Line Railroad founded the town site and named it Sarles, but because of duplication the Adams name was used. (248) 1923

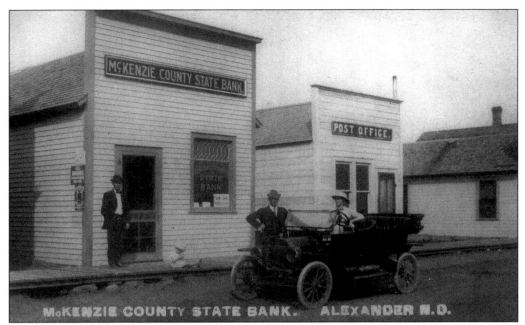

ALEXANDER (McKenzie). The town site was plotted in 1905 and was the county seat when McKenzie County was organized, but it lost the honor to Schaefer in 1909. The first buildings were the Dakota Trading Company and the Alexander State Bank. Arthur A. Link, former governor of North Dakota (1973–1981), was born here in 1914. (216) 1922

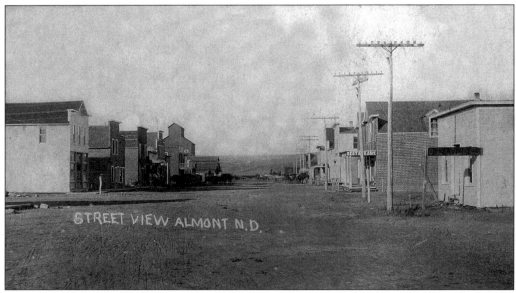

ALMONT (Morton). Almont was developed in 1906 when settlers decided that the property was too expensive in nearby Sims. Lots at Almont were selling for $100 each. The businessmen of Almont arranged for a first anniversary celebration, with a baseball game, horse and foot races, and a dance. (117)

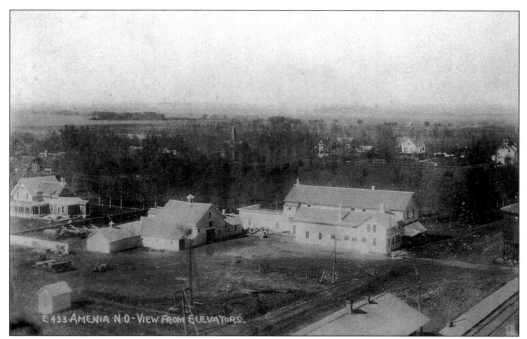

AMENIA (Cass). By 1886, Amenia had a store with two sets of rooms upstairs and the Land Company office and post office downstairs. Also in town was the blacksmith shop, the red granary built in 1876, and the round elevator with its warehouse and flour mill. In 1898, work started on the town's water main. A flax mill was built in 1899 and was used until 1912. (82)

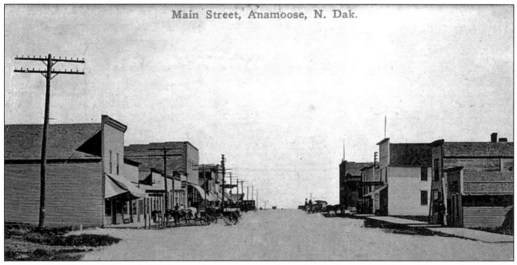

Main Street, Anamoose, N. Dak.

ANAMOOSE (McHenry). This settlement was founded about 1893 by Romanians who came from Saskatchewan, Canada. There were four blocks in the business section on Main Street. Among the businesses was a cement block factory that supplied the blocks used in all such buildings in town. Cement mixing, hauling, and block molding were done by hand. (277) 1913

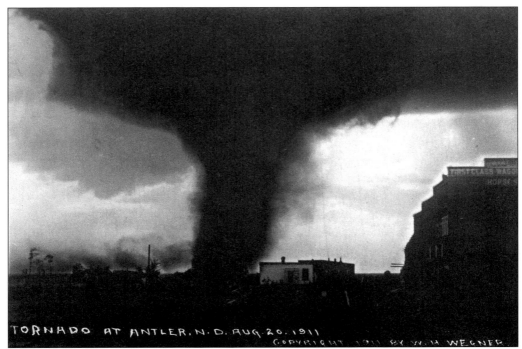

TORNADO AT ANTLER, N. D. AUG. 20. 1911
COPYRIGHT 1911 BY W. H. WEGNER

ANTLER (Bottineau). The name was chosen because of its location near Antler Creek, so named because its north and south branches resemble the antlers of a deer when drawn on a map. Harley Kissner brought national attention here in 1981, when he offered free land to families with children who would move to Antler. The intent was to keep the school open, and the plan worked for a few years. (74) 1908

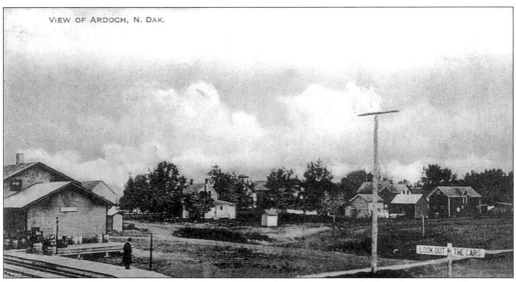

VIEW OF ARDOCH, N. DAK.

LOOK OUT THE CARS

ARDOCH (Walsh). The first settlers called this place Kimball. The post office was established in 1882, and the postmaster named it for his hometown of Ardoch, Ontario, Canada. Notice the crossroad sign on the postcard: "LOOK OUT-THE CARS." (49) 1918

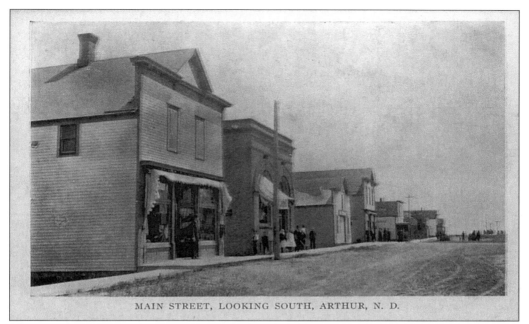

MAIN STREET, LOOKING SOUTH, ARTHUR, N. D.

ARTHUR (Cass). Salesmen would get off the train and rent a horse to peddle their goods between Arthur and Hunter. There had been two stores in Arthur—one Republican and the other Democrat—and the post office was located in the back of the stores. Whenever the federal administration switched parties, the post office would switch stores. This caused so much confusion that a separate post office building was eventually set up. (400)

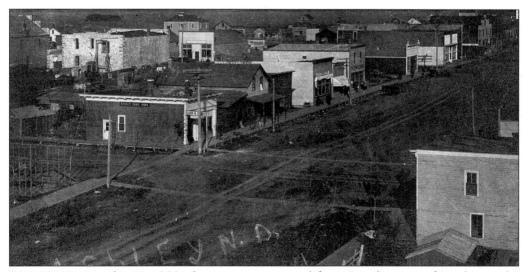

ASHLEY (McIntosh). In 1888, the town was moved from 3 miles east of Hoskins Lake to be near the railroad. There were 38 telephones in town in 1906. The Milling Company allowed farmers to bring in wheat in exchange for flour. Many early residents of Ashley were from the German-Russian movement. In 1906, several Jewish families bought land north of town. (1,052) 1908

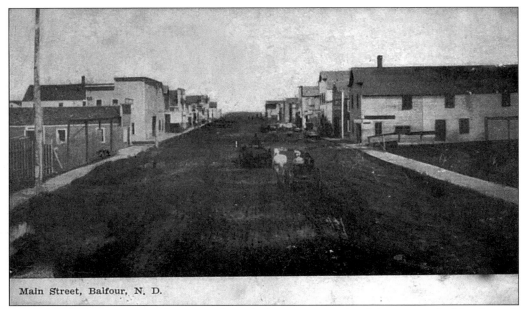

Main Street, Balfour, N. D.

BALFOUR (McHenry). Balfour was founded in 1899 on land homesteaded by Patrick O'Hara. The town was named by Soo Line Railroad officials in honor of Lord Balfour, Prime Minister of Ireland. It incorporated as a village in 1921 and reached a peak population of 399 in 1910. (33) 1908

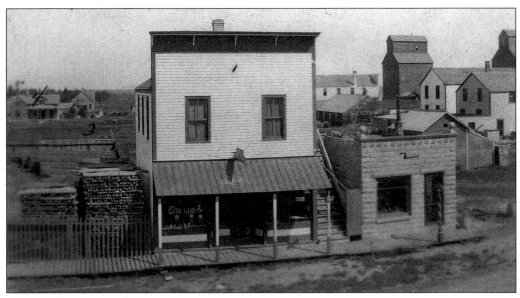

BARLOW (Foster). Barlow was named for Frederich George Barlow (1839–1901), the town's founder and first merchant. The larger building shown above was the drug store, and next to it was the barbershop. Mr. Barlow was elected to the first legislature of North Dakota and also served as a senator. It was through his untiring efforts that North Dakota entered the union as a dry state.

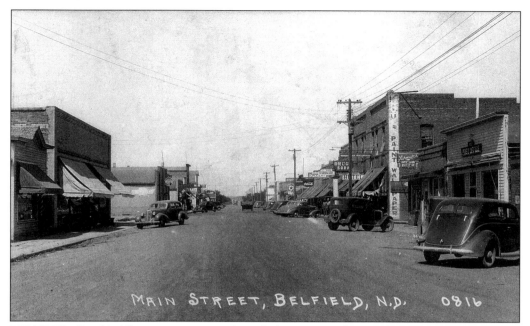

MAIN STREET, BELFIELD, N.D. 0816

BELFIELD (Stark). The town site was founded in 1883. The city had a population of 50 in 1890, but grew rapidly after Ukrainian settlement began in 1897. Water was found in abundance by digging shallow wells. (887)

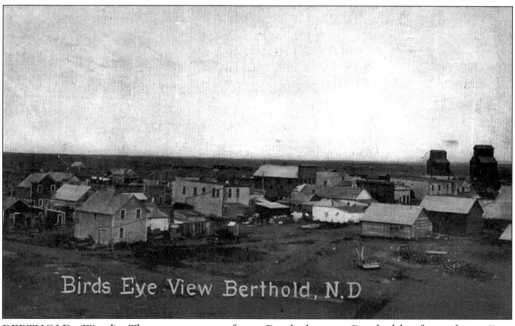

Birds Eye View Berthold, N.D

BERTHOLD (Ward). The name came from Bartholomew Berthold, after whom Fort Berthold was named. For a short time school was held in the depot, but in 1905 a four-room brick school was built, and in 1910 there were four rooms added to the upper story. In about 1926, the gymnasium was added. (409)

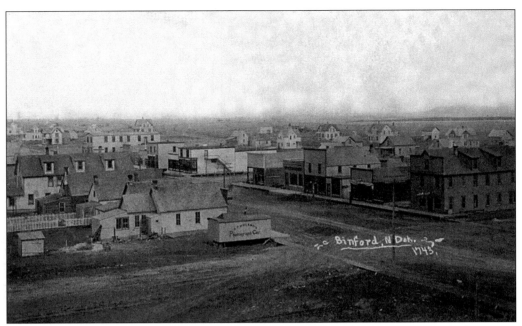

BINFORD (Griggs). Binford was sometimes known as "Blooming Prairie." The outer walls of the present post office were made of cement blocks manufactured at a small block factory located near Lake Sibley. (233)

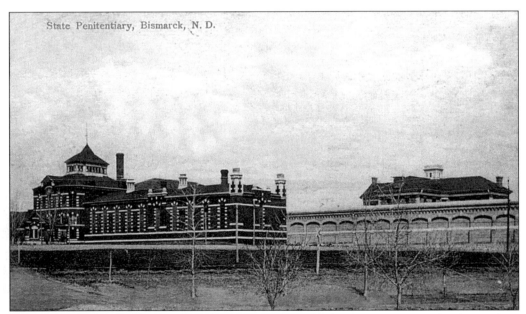

BISMARCK (Burleigh). In 1911, the first motor vehicle registration took place when 7,201 licenses were issued. At that time, dirt paths were the only roads. The first paved road in the state was laid from Mandan through Bismarck to the penitentiary. (49,256)

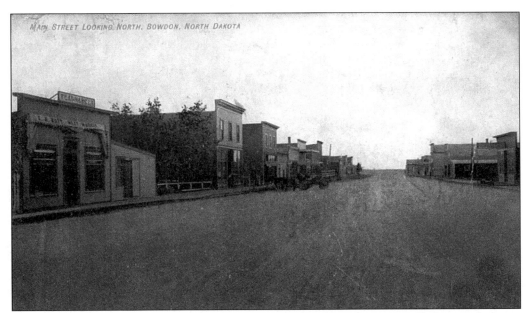

BOWDON (Wells). In 1900, a portion of a long immigrant train pulled into the new little town. It brought immigrants from the eastern states who had come west to make their homes. This immigration train had left Chicago three days earlier, bound for North Dakota. (196)

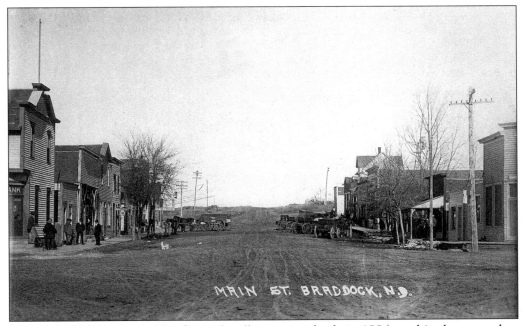

BRADDOCK (Emmons). The first schoolhouse was built in 1884, and it also served as a church on Sundays. In 1899, the General Store was busy selling stylish hats, nubby hosiery, suits, butter, eggs, and other groceries to the early settlers. The firm was giving away a set of glass dinnerware with a purchase of $5 or more. (56)

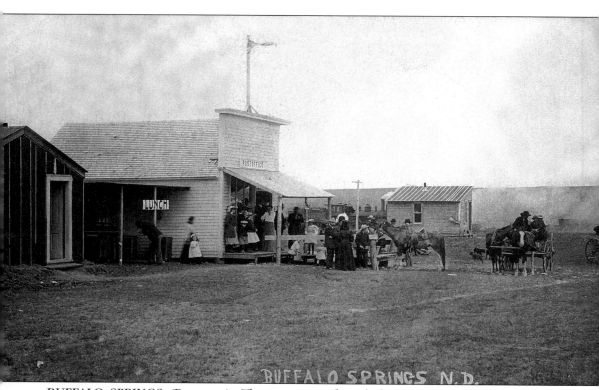

BUFFALO SPRINGS (Bowman). The town was founded as Ingomar, but after a few months was changed to Buffalo Springs. It was named for the watering spot on Buffalo Creek. The Buffalo Springs Lake was formed in 1907 by the construction of a dam on Buffalo Creek, built by the railroad to supply their engines with water. Trees were planted, and this grew to be a popular spot for picnics, swimming, and hunting. (40) 1910

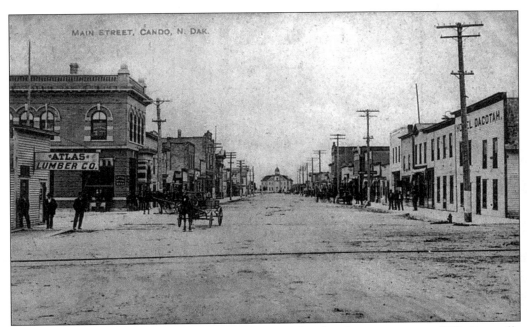

CANDO (Towner). This site was selected in 1884 to be the county seat. J.W. Connally objected to this, but was told by Commissioner Prosper T. Parker that, in fact, they did have the power to do this and proposed the name "Can Do" to prove it. (1,564) 1910

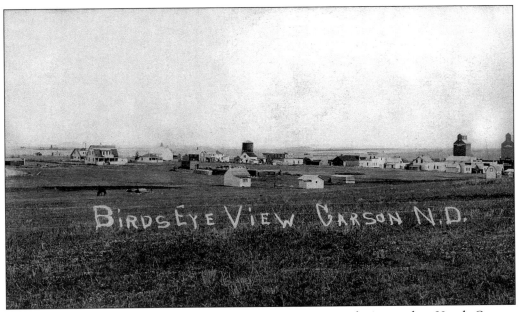

CARSON (Gran:). At one time there were two towns, one designated as North Carson and the other as Old Carson. The latter boasted a store, post office, and coal mine about 1 mile south of the present site of Carson. The twin North Carson settlement was 2 miles north. The arrival of the railroad in 1910 brought about a merger of the two towns. (383)

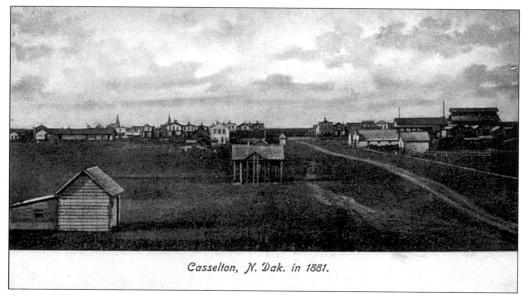

Casselton, N. Dak. in 1881.

CASSELTON (Cass). Casselton incorporated as a village in 1880 and as a city in 1883. M.G. Strauss, the clothing store founder, began his business here in 1897. William Langer was born here in 1886. George A. Sinner and A.H. Burle, former governors of North Dakota, were also residents here. (1,601) 1907

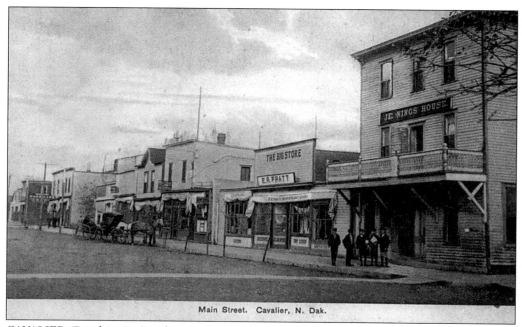

Main Street. Cavalier, N. Dak.

CAVALIER (Pembina). Cavalier was named for explorer Rene Robert Cavalier, Sieure de la Salle (1643–1687). It replaced Pembina as the county seat in 1911 because of its central location. The first business was a gristmill and sawmill built of hewn oak logs, founded in 1881. (150) 1909

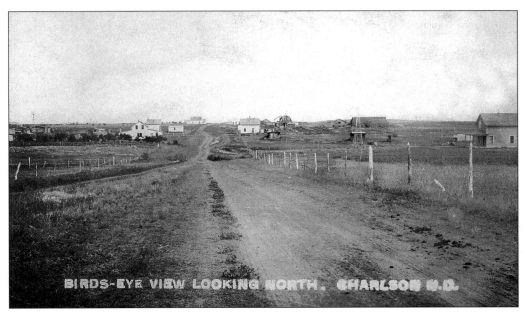

CHARLESON (McKenzie). This rural post office was established in 1904, with Thorsten E. Charleson postmaster at his home. In 1907, he plotted the town site, though the village never incorporated.

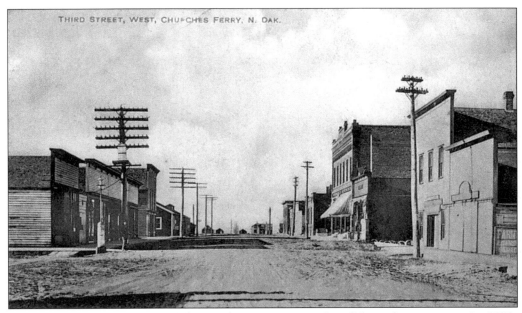

CHURCHS FERRY (Ramsey). This settlement on a coulee did not have a name in 1883. Irvine Church was conducting the ferry across the coulee, and thus it happened that the village was named Churchs Ferry. The ferry service ended when the coulee dried up. (118) 1914

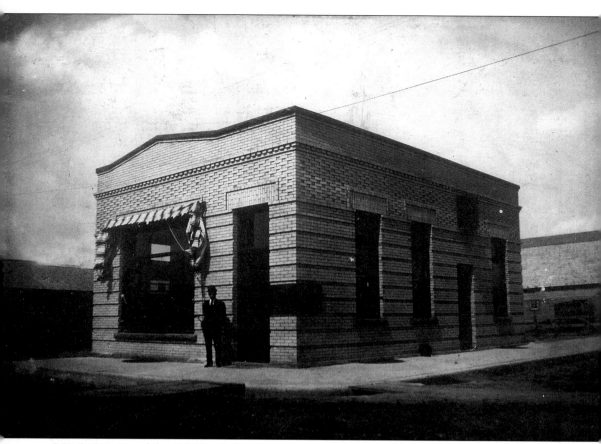

COLGATE (Steele). (1910) Colgate was named for James B. Colgate, who was the county's largest landowner. He was the son of William Colgate, founder of what became the Colgate Palmolive Company. Colgate was a thriving town until the surrey cut-off railroad was completed in 1912. Business then started to decline. Stores began to close, and people began to leave town. The bank closed in 1927, and depositors were paid 40¢ on the dollar.

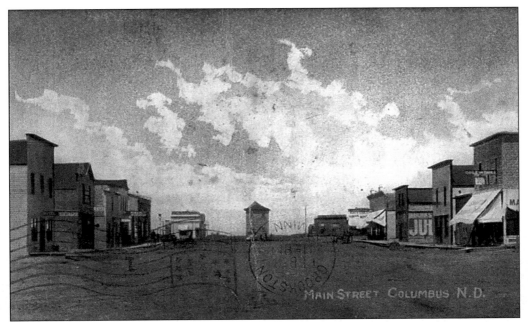

COLUMBUS (Burke). A flour mill was built near the railroad track, where a high grade of flour and cereal products was ground from the wheat grown in the area. It was run by a Corliss steam engine with two boilers, later replaced by diesel motors. This engine used to run the mill and furnished the first electricity in town. (233) 1916

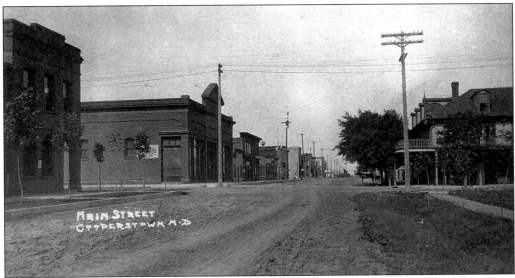

COOPERSTOWN (Griggs). Cooperstown became the county seat in 1882, taking the honor from Hope, which served as the county seat at the time. Cooperstown was, at the time, only a plot on paper. It was named for bonanza farmer Rollin C. Cooper (1845–1938) and his brother Thomas. (1,247) 1908

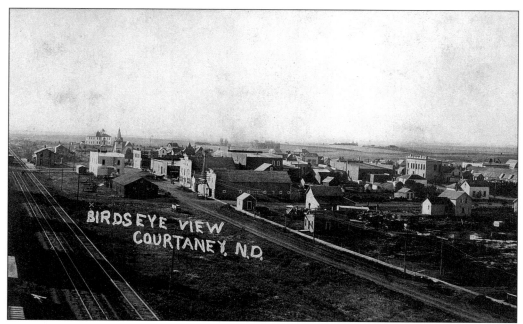

COURTNEY (Stutsman). Courtney was incorporated as a village in 1902 and reached a peak population of 539 in 1910. A general merchandise store, restaurant, and elevators were the only businesses until the summer of 1893. (70) 1908

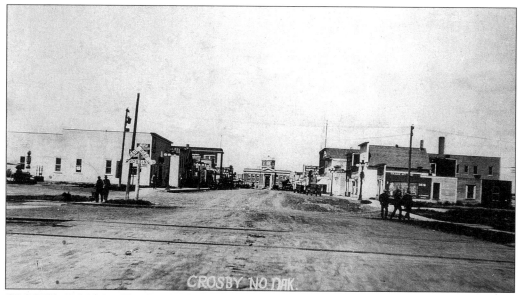

CROSBY (Divide). Charlie Anderson was a familiar character in this town. He had a small team of mules and used to shovel coal out of the boxcars to deliver it around town. He also hauled many barrels of water on a stone boat and delivered them to various homes. (A stone boat is a heavy sled-like affair pulled on skids). (145)

Two
DAZEY TO FREDONIA

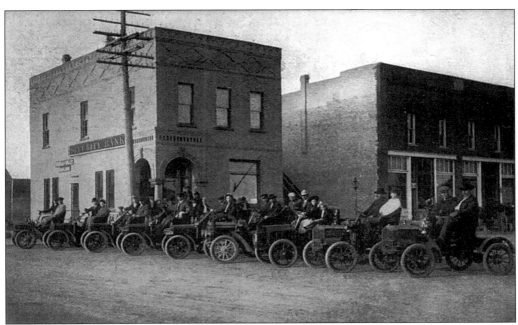

DAZEY (Barnes). Dazey was named for Charles Turner Dazey (1855–1938), who came here in 1882 to start a bonanza farm and donated the land for the town site. The Community Telephone Company was organized in 1904, and a year later a feed, flour mill, and the first newspaper were established. (129) 1909

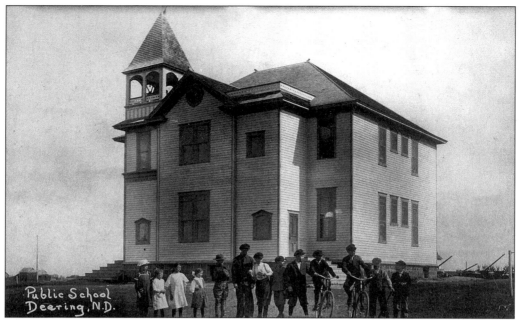

Public School
Deering, N.D.

DEERING (McHenry). Deering was founded in 1903. It was named for William Deering of the Deering Harvestor Company of Minneapolis, Minnesota. The school was established in 1923 and was one of the finest of its time, with an excellent gymnasium. In 1927, the undefeated Deering basketball team won the state championship. (99)

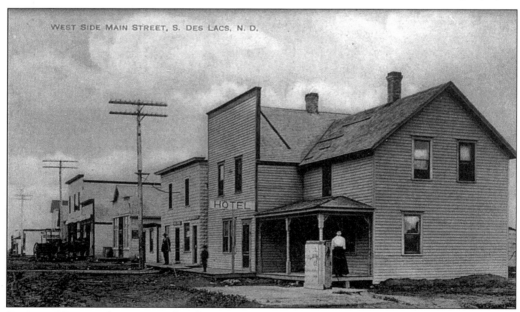

WEST SIDE MAIN STREET, S. DES LACS, N. D.

DES LACS (Ward). Originally the name was spelled as one word to comply with government regulations. It was organized in 1900 when Fred Becker built a house near the Great Northern depot and section house. The village received national attention in 1922, when all eight elective positions were captured by women. (216)

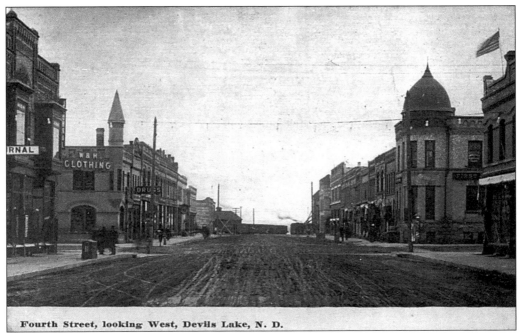

Fourth Street, looking West, Devils Lake, N. D.

DEVILS LAKE (Ramsey). The town was originally named by its founder, Lieutenant Herbert M. Creel, who surveyed a town site on the north shore of the lake in 1882, naming it Creelsburgh. In 1883, the post office renamed it Creel City, but the name Devils Lake was adopted a year later. William L. Guy, governor of North Dakota from 1961 to 1973, is a native son. (7,782) 1908

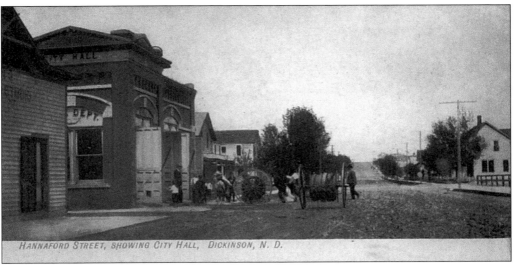

HANNAFORD STREET, SHOWING CITY HALL, DICKINSON, N. D.

DICKINSON (Stark). This site was named Pleasant Valley Siding in 1880, but was renamed in 1881 for Wells Stoughton Dickinson (1828–1892), a land agent who had visited here in 1880. Dickinson State University initiated here in 1931. One of the town's earliest businesses was the Beckette and Foote hide-buying store. The only fresh meat sold at the meat market was buffalo, elk, deer, and antelope. (16,097)

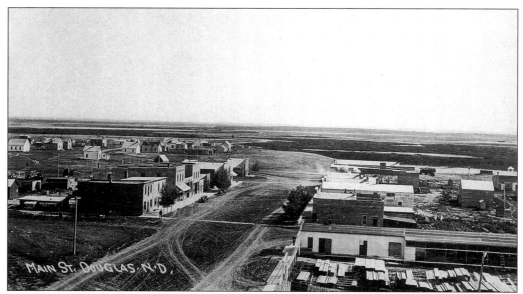

DOUGLAS (Ward). This town site was founded along the newly-built Soo Line Railroad. The land on which the town now stands was a government school section in 1905. An ad in the 1907 *Douglas Herald* by the Douglas Land Agency stated that they had 149,000 acres of land for sale at $3.75 per acre. (93)

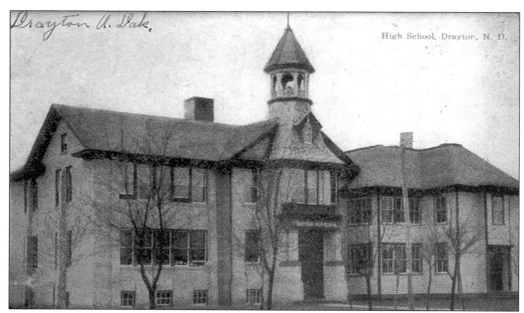

DRAYTON (Pembina). A ferry was operated on the river for many years in order to connect the city with the trade area to the east. A bridge that was intended to lift for the passage of steamboats was erected in 1911. After the bridge had been completed, the river stage fell and never rose again. The bridge has never been lifted. (961) 1911

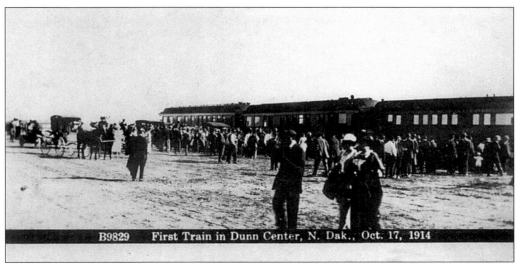

B9829 First Train in Dunn Center, N. Dak., Oct. 17, 1914

DUNN CENTER (Dunn). Dunn Center was first established 1.5 miles east of its present site in 1913. The railroad arrived in 1914, and the newly-built town had to pull stakes and move to the present site. A flour mill was constructed in 1915—besides milling flour and grinding feed, it generated power and electricity for the homes and businesses in town. (128) 1914

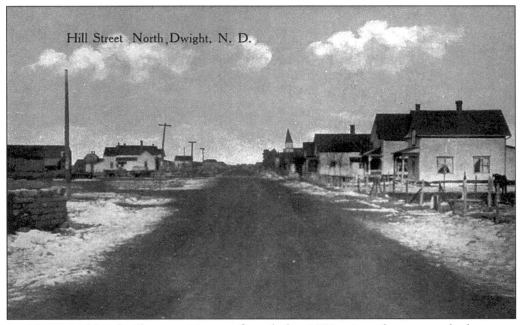

Hill Street North, Dwight, N. D.

DWIGHT (Richland). The town site was founded in 1880 primarily to serve the bonanza farm owned by Jeremiah Dwight (1819–1855), a congressman from New York, who owned 27,000 acres of land in the county. The first hotel was established in order to accommodate the men from the East who had answered ads for work on the farm. Eventually, there were 200 men on the farm's payroll. (83)

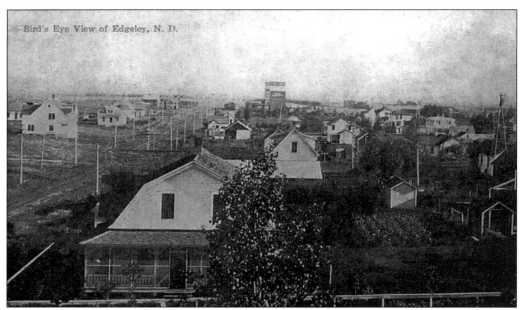

Bird's Eye View of Edgeley, N. D.

EDGELEY (LaMoure). The first buildings in the town were a large two-story depot, a two-stall engine house, a section house, a coal house, and a grain flat. The message on this card reads: "I am getting twenty-seven cents an hour. I put in fifteen hours yesterday and nine today. Board is a dollar a day. I will be home as soon as I see that it won't pay." (680)

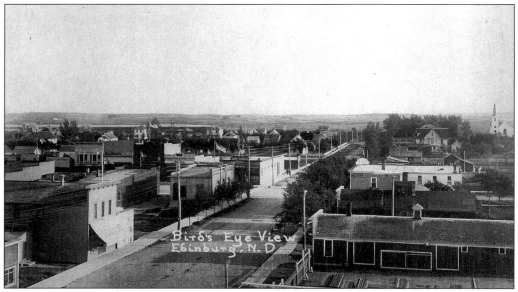

Bird's Eye View Edinburg, N. D.

EDINBURG (Walsh). Around the same time this young town was developed, it was hit by the biggest disaster in its history. In 1900, the entire business section was destroyed by fire in the course of two hours. The economic loss was enormous, yet, in a year's time almost every business was rebuilt, and consequently Edinburg erected larger and more significant structures than the town had ever hoped for. (284)

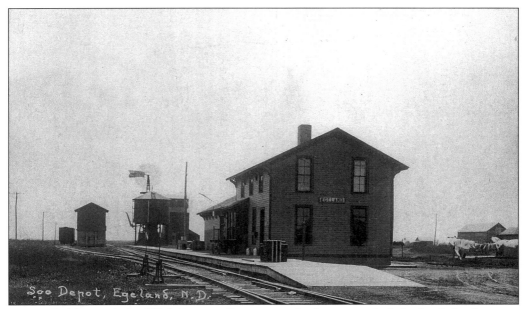

EGLAND (Towner). In 1894, Rasmus Rasmussen Sr. homesteaded the land that became this town site in 1905. With the prospect that Egland would be a railroad junction, it became a boom town and incorporated in 1905. (103) 1912

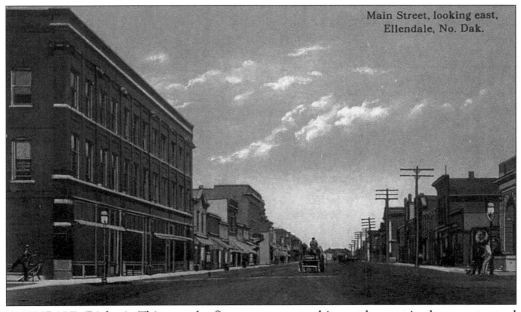

ELLENDALE (Dickey). This was the first permanent white settlement in the county, and it became the county seat in 1882. A state teachers college was located here from 1899 to 1970. (1,798)

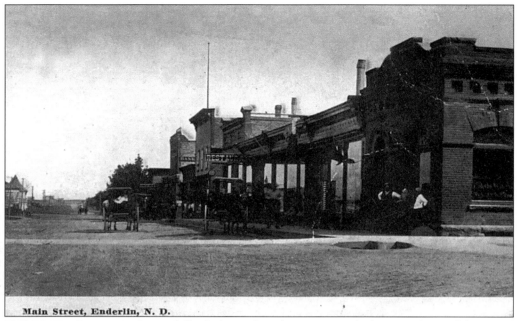

Main Street, Enderlin, N. D.

ENDERLIN (Ransom). Some folks believe that the name Enderlin was derived from the German workers in the region when it was the terminus of the Soo Line branch, or the "end der line." (997) 1916

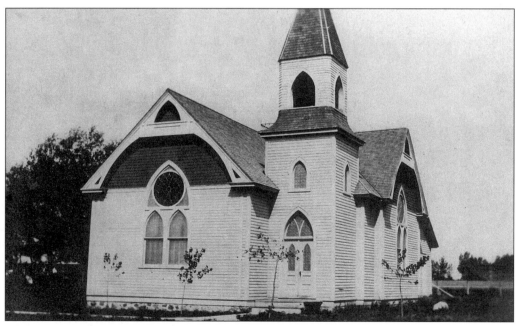

ERIE (Cass). The Great Northern Railroad Station was built in the spring of 1882. This Methodist church was built in 1899 and was dedicated by Bishop Isaac W. Joyce. After the sermon and dedication, the audience was invited to repair to the Workman Hall for a hour or two of socializing and a free lunch. 1909

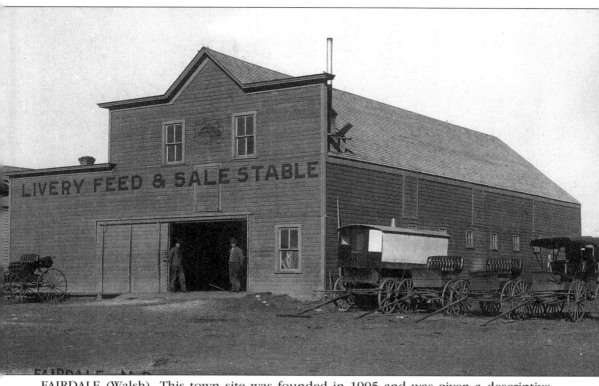

FAIRDALE (Walsh). This town site was founded in 1905 and was given a descriptive name noting its pleasant location in the Park River Valley. Al Van Dahl, the pioneer editor of *The Fairdale Times*, later achieved success in Mill City, Oregon, as the publisher of *The Western Stamp Collector*, a national periodical serving that popular hobby.

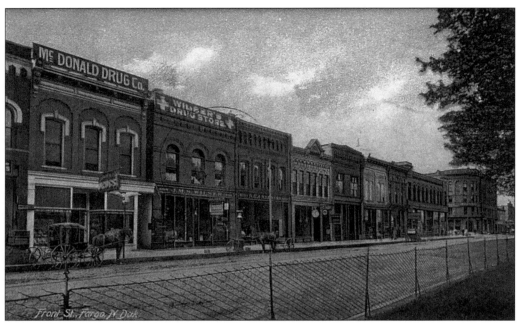

FARGO (Cass). Life began here in a roaring, robust camp during the winters of 1871 and 1872. The first inhabitants were a hard-drinking lot who created a tent city composed of many saloons, bordellos, and a few more legitimate places of business. (74,111)

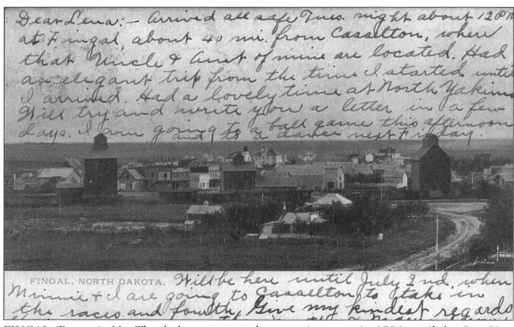

FINGAL (Barnes). Mr. Thorkelson operated a store in a tent in 1891 until the Soo Line Railroad reached the site. The station agent maintained his headquarters in a boxcar, and the depot was built the following year. (138) 1906

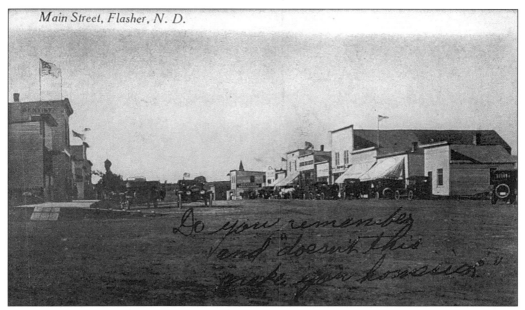

Main Street, Flasher, N. D.

FLASHER (Morton). William H. Brown was the founder of the town site in 1902, and it was named in honor of Miss Mable Flasher, his personal secretary. The telephone line here was built from Mandan to Flasher in 1909. In 1916, when Grant and Morton Counties were divided, Flasher campaigned to be the county seat, but lost to Mandan because of their larger population. (317) 1913

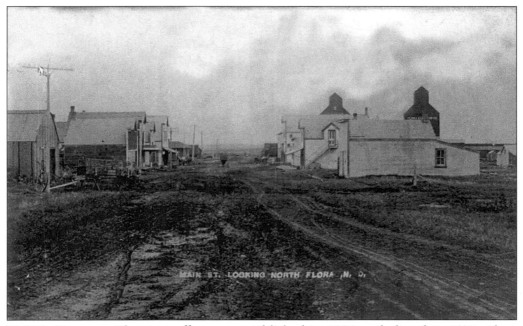

FLORA (Benson). The post office was established in 1901 and closed in 1971. Flora reached its peak population of 100 in 1920. According to folklore, the town was named for Flora Bjerken, a popular lady in the area. 1915

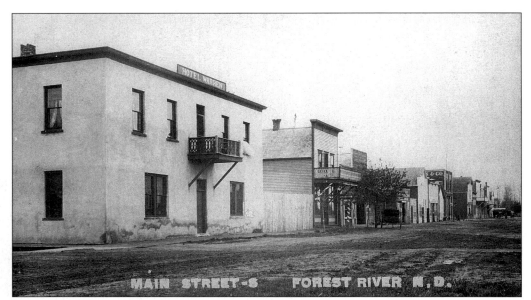

FOREST RIVER (Walsh). Many early settlers arrived in this area via Fisher's Landing. Boats traveled regular routes between the Landing and Winnipeg, Manitoba, Canada. Because it was the head of navigation, the railroad tracks were laid to meet the boat traffic in 1875. With the extension of the railroad to Grand Forks and the ever-changing river depths, river traffic declined and the village moved to its present site—up the riverbank to higher ground. (148)

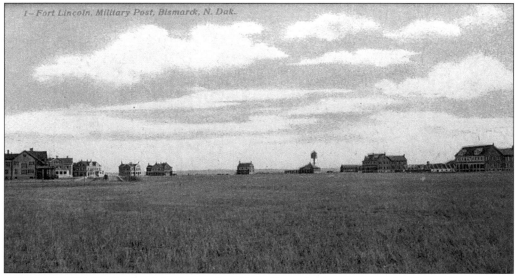

FORT LINCOLN (Burleigh). In reality, Fort Lincoln is composed of two forts—Fort McKeen, staffed in 1872 as an infantry post, and Fort Lincoln, staffed in 1873 as a cavalry post. It served as the headquarters of General George Custer. In 1882, the 7th Cavalry transferred to Fort Meade, and the infantry transferred in 1890. The fort was officially abandoned in 1891. In 1903, a new post—Fort Lincoln—was established south of Bismarck.

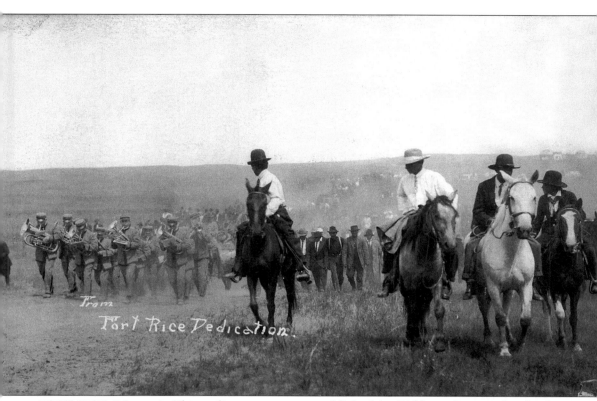

From
Fort Rice Dedication.

FORT RICE (Morton). This military post was established in 1864 on the west bank of the Missouri River, a few miles above the mouth of the Cannonball River. It was the second fort built by General Sully in what is now the state of North Dakota. It played major roles in Indian campaigns and railroad construction until it was replaced in 1878 by Fort Yates. All the original buildings have since been dismantled. It was made into a state park, and a replica fort was built by the WPA in the 1930s. This postcard depicts the dedication of the fort.

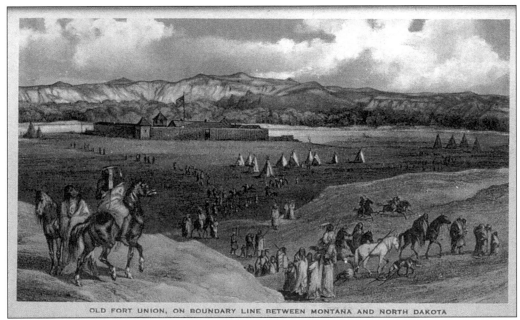

OLD FORT UNION, ON BOUNDARY LINE BETWEEN MONTANA AND NORTH DAKOTA

FORT UNION (Williams). This historic fur trading post was built in 1828 as Fort Floyd. In 1830, it was renamed Fort Union to honor the merger of the American Fur Company and the Columbia Fur Company. Corruption by officials led to the post's termination in 1865. However, much of the material was salvaged to build the military post of Fort Buford 3 miles downstream in 1866.

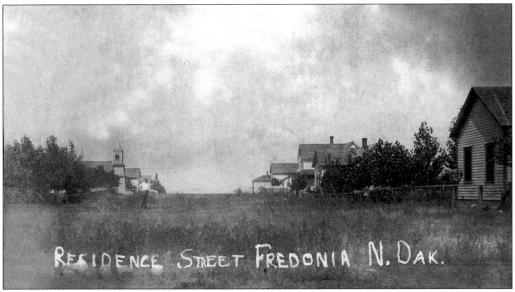

RESIDENCE STREET FREDONIA N. DAK.

FREDONIA (Logan). This village was founded along the Soo Line Railroad in 1904 and named Denevitz. When the post office opened in 1905, the name was changed to Fredonia. Some of the first buildings established in 1904 included a general store, grain elevator, lumberyard, and a meat market. (66) 1914

Three
GACKLE TO JUD

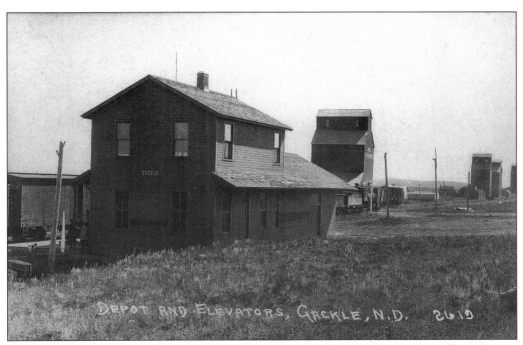

GACKLE (Logan). The village was once known as Hacknet and was also referred to as Minister for a time. It was named Gackle in honor of Mr. George Gackle. One of the highlights of the early years of the town was the completion of the railroad in 1905. A depot was established on the northeast edge of town, but it had to be moved because of the swampy conditions that developed each spring. (450)

GALCHUTT (Richland). This Great Northern Railroad town was named for Hans Galchutt, who came here in 1882 and built a store, a warehouse, and an elevator. There was a livery barn here until 1916, where the horses that were used to carry mail from Wahpeton to Dwight were kept. A horse was waiting at Dwight for the carrier, and when he arrived in Galchutt, another horse was ready to carry the mail to Colfax.

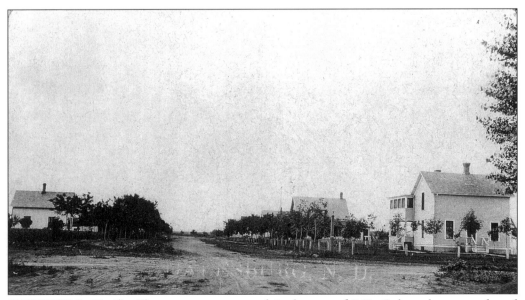

GALESBURG (Trail). The town was named in honor of J.H. Gale, who owned and plotted the site in 1883. The first business in town was a general store, built in 1882, where most of the commerce in town was conducted. (161)

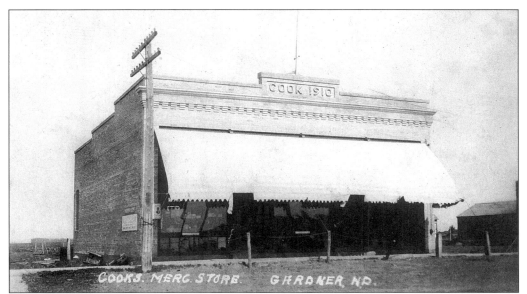

GARDNER (Cass). Gardner was incorporated in 1929 and named for Stephen Gardner, an extensive landowner in the area. The school in town was a two-room building constructed in 1895. The Minneapolis and Northern Elevator was built in 1883 and was powered by a steam boiler—the only one of its kind in the area. (85)

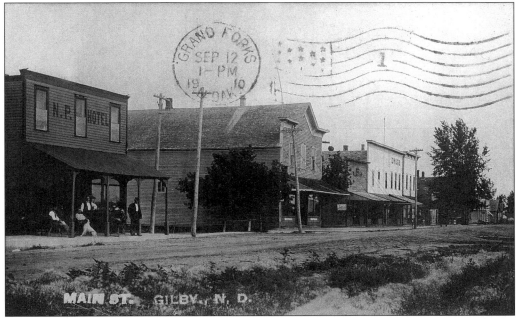

GILBY (Grand Forks). Gilby was named for John Gilby Jr., one of the Gilby brothers who came to this area in 1878. The railroad construction crew set up a tent town on the north bank of the coulee. The first building, a saloon, was hauled in on a wagon from Ardoch. (262) 1910

GLADSTONE (Stark). The Roller Mill was completed in 1885. Local citizens had a basket picnic at the mill. The first wheat bought for the mill cost 60 or 65¢ per bushel, and oats were 30¢ per bushel. Other prices of goods in Gladstone in 1885 were: $3.25 for 100 pounds of flour, $1.00 for 9 pounds of sugar, 20¢ a pound for porterhouse steak, and 5¢ per pound for antelope. (224)

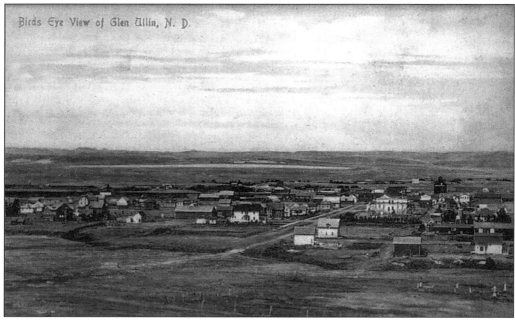

Birds Eye View of Glen Ullin, N. D.

GLEN ULLIN (Mortin). From 1895 to 1905, the name Glen Ullin was spelled as one word to conform to government spelling regulations, and from 1883 until 1949, the Northern Pacific Railroad depot displayed the town's name as Glenullin. The population when Glen Ullin was incorporated as a city in 1910 was 921. (927)

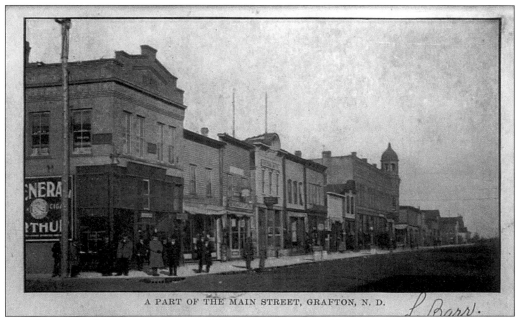

A PART OF THE MAIN STREET, GRAFTON, N. D.

GRAFTON (Walsh). According to folklore, postmaster Thomas E. Cooper planned to raise fruit in the area by grafting branches on trees, and used the term graft-on. The State Institute for the Feeble-minded was founded here in 1903. (4,840) 1907

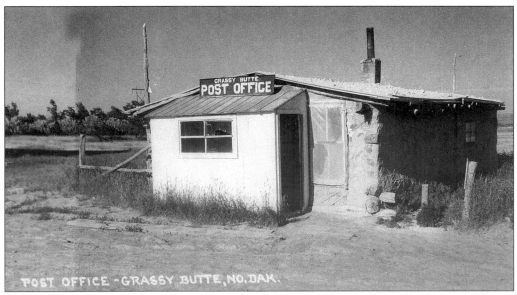

POST OFFICE - GRASSY BUTTE, NO. DAK.

GRASSY BUTTE (McKenzie). This settlement was named for one of the neighboring buttes that has long been a landmark—Grassy Butte is the only one not bare of vegetation. The post office here was established in a sod house in 1913. In the settlement's early days, when there were buildings on only one side of Main Street, a local saying was: "Grassy Butte has the widest Main Street in the country—from here to the Atlantic Seaboard."

HALEY (Bowman). This settlement began in 1898 as Galey, named for William Galey, who discovered gold near here in 1887. An error by postal officials resulted in the post office being established as Haley. J.E. Crawford, one-time postmaster, is credited with being one of the first to conceive of the idea of a dam here on the Grand River. 1909

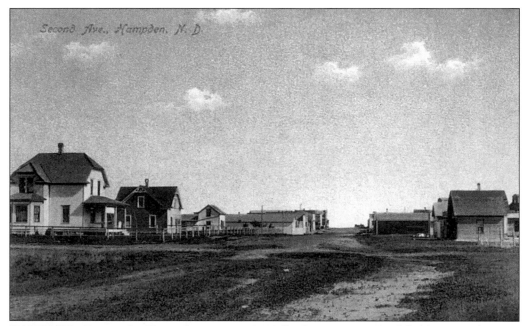

HAMPDEN (Ramsey). Hampden was originally known as Northfield. According to folklore, a man came into a restaurant and asked for a sandwich—either beef or pork. Since they had neither, he said, "Gimme ham den." The name was subsequently changed to Hampden, since the mail was often confused with Northfield, Minnesota. (89)

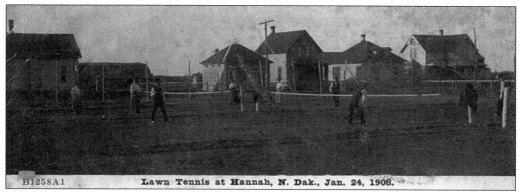

B1258A1 Lawn Tennis at Hannah, N. Dak., Jan. 24, 1908.

HANNAH (Cavalier). Hannah was named for Frank Hannah, who came here in the early 1880s. The peak population of 262 was reached in 1930. The community organized a weekly newspaper whose office was set up in a granary in 1896. (49) 1909

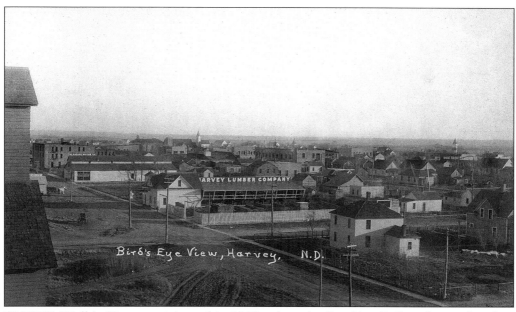

Bird's Eye View, Harvey, N.D.

HARVEY (Wells). Harvey originated in 1893, when the Soo Line Railroad completed its line to Portal. The first business in town was operated in a tent and involved selling general store items. "Harvey—Cob of the Corn Belt" and "Home of the Tuber," were slogans generated to advertise the town. (2,263)

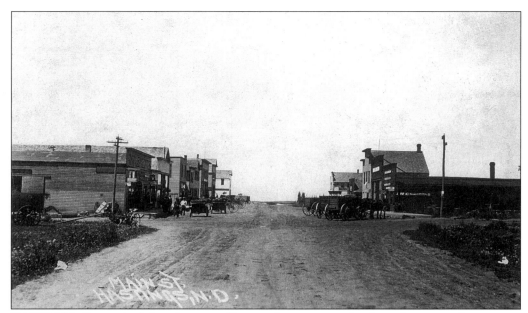

HASTINGS (Barnes). A hotel, post office, and store were built at the time of Hastings' establishment, and a blacksmith shop, elevator, hardware store, and a restaurant were built later. The town's bank was built in 1917. Hastings reached its peak population of 199 in 1930. 1910

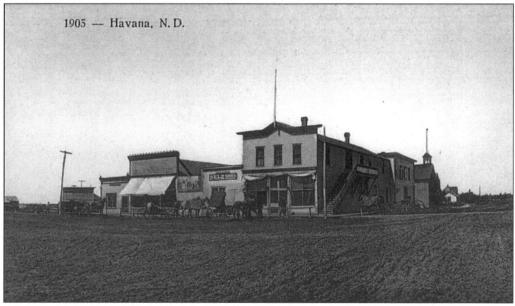

HAVANA (Sargent). Havana was established in 1881 by Henry Weber, for whom the township is named—for a time the town was known as Weber. When the railroad came in 1886, the Great Northern Railroad called the town by its present name. Havana received national attention in 1987 when it kept its cafe open by operating with volunteer labor provided by local residents. (124)

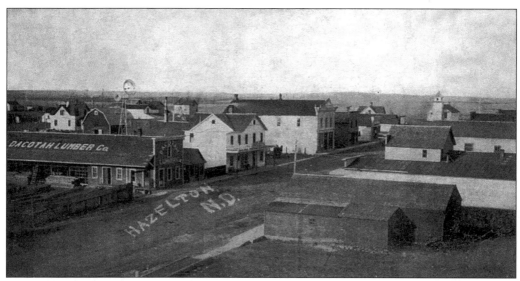

HAZELTON (Emmons). In 1902, a farmer plotted a town site on the border of the right-of-way and named it Hazelton after his daughter, Hazel. In 1903, actual construction of the town began. It has been self-proclaimed "The Flax Capital of the Nation." (240) 1909

HENSEL (Pembina). This is the only town in the county with two names—Canton Village, its legal name, and Hensel, its nickname. The barber shop and pool room sold candy and soft drinks.

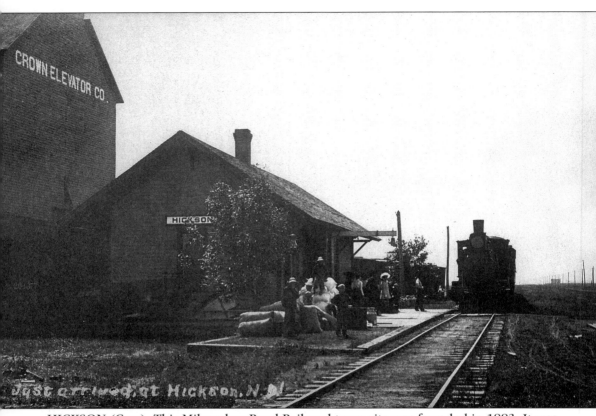

HICKSON (Cass). This Milwaukee Road Railroad town site was founded in 1883. It was plotted by Richard S. Tyler, a Fargo real estate promoter who controlled most of the town sites on this railroad, which was then known as the Fargo and Southern. The village never incorporated and reached a peak population of 125 in 1890.

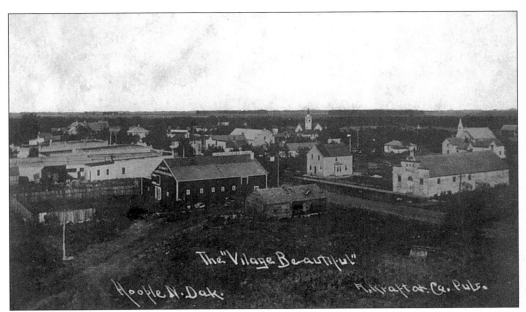

HOOPLE (Walsh). The Folson Potato Company was the first to ship potatoes out of the state in 1907. Now potato warehouses line the railroad tracks in town. With all these warehouses, it is obvious why Hoople is known as "Tater Town, U.S.A." The inscription on the card above calls it the "Village Beautiful." (310) 1907

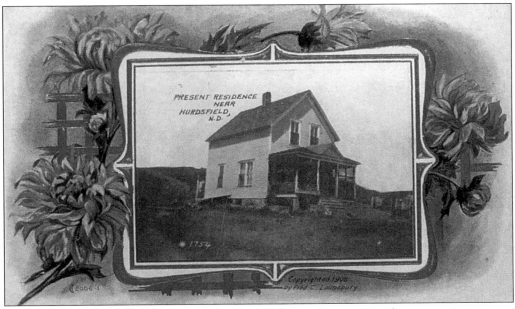

HURDSFIELD (Wells). Hurdsfield was named for Warren Hurd, a prominent area farmer and developer. Mr. Hurd built the famous round house in 1900 as a land office. The two-story house derives its name from the circular porch floor and cut-stone foundation, and it was named to the National Register in 1977. This postcard shows the Hurd Ranch House. (92) 1911

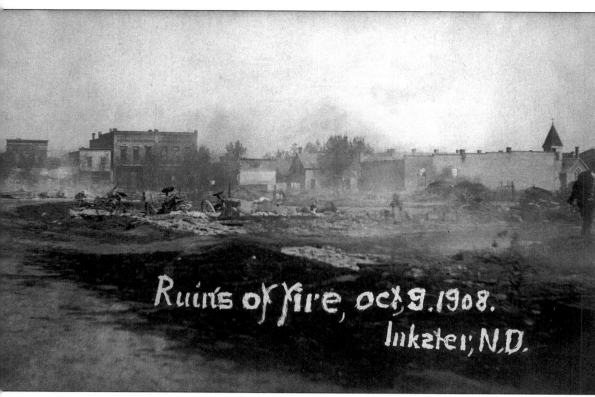

Ruins of fire, oct 9.1908.
Inkster, N.D.

INKSTER (Grand Forks). This depot was built in 1884. By 1887, the population reached 411. Inkster was one of the most beautiful cities in the area before a fire in 1908 destroyed many of the buildings. That same year, Inkster proposed to vote on bonds to build a $25 schoolhouse, and a brick building was erected.

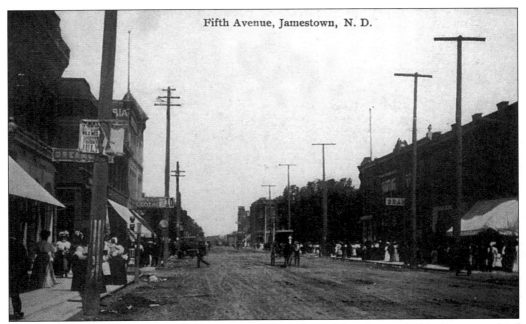

Fifth Avenue, Jamestown, N. D.

JAMESTOWN (Stutsman). This town site was selected by General T.L. Rosser, chief engineer of construction for the railroad. The location of this town on the James River prompted him to name it Jamestown. A.W. Kelley was appointed postmaster in 1872, with the salary of $1 per year. He also operated a general store in this tent town. (15,571)

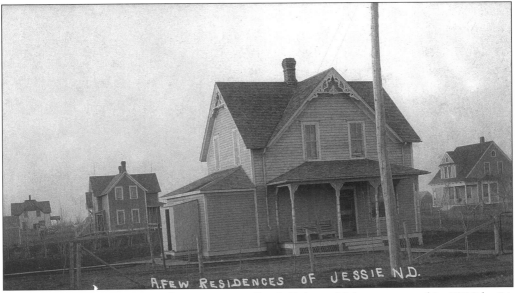

JESSIE (Griggs). The town of Jessie is near Jessie Lake, which was named in 1939 by Lt. John C. Fremont, the famous explorer, for his fiancee Jessie Benton. It was plotted in 1899, large frame houses were built, and a few businesses sprang up. By the late 1920s, many of these businesses had gone broke. The population never exceeded 100.

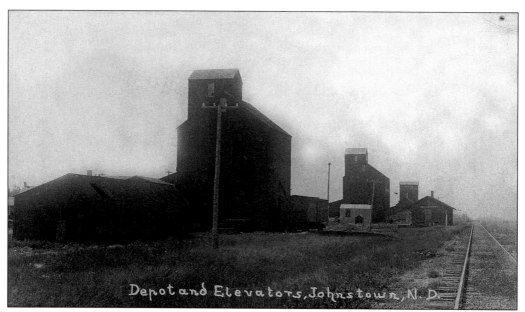

Depot and Elevators, Johnstown, N. D.

JOHNSTOWN (Grand Forks). The post office and township was originally named Milan by John Ryan Barker, the first postmaster. He named them for his former hometown of Milan, Pennsylvania. The name changed to Johnstown when the township was renamed the same.

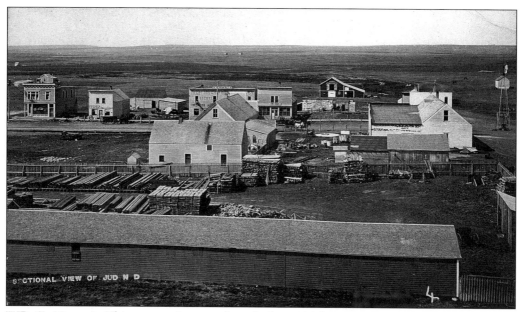

SECTIONAL VIEW OF JUD N D

JUD (LaMoure). This town site was founded in 1904 in anticipation of the Northern Pacific Railroad, which arrived in 1905. It was plotted as Fox, but the post office was established as Gunthrop. In 1906, the name was changed to Jud to honor Judson LaMoure (1839–1918), the famous politician who was the namesake of the county. (84)

Four
KATHRYN TO MOTT

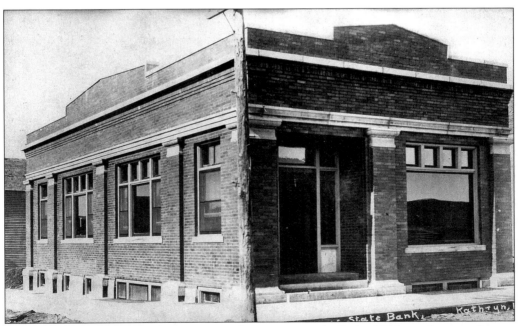

KATHRYN (Barnes). The first store in this town was built in 1900, and a year later a restaurant and post office were established. In 1902, a farm implement and furniture store were added. Kathryn was made famous as the home of Gustof George Overn, a jeweler and expert gold and silversmith. Orders came in from many states as his work was considered outstanding. (72)

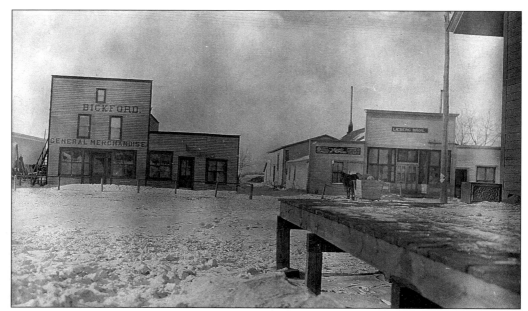

KEMPTON (Grand Forks). This new town site was named for W.S. Kemp, a railroad employee at that time. Kempton offered a variety of trades—recreation, confectionary, grocery business, bowling alley, and community hall. Elmer Bickford was appointed the first postmaster in 1887. The message on this card states: "Dad was agent here from 1905 to 1922."

KENSAL (Stutsman). Kensal was named by local settlers for Kensale, a sporting town and watering place in County Cork, Ireland. The "e" was dropped from Kensal in its early years. The village incorporated in 1907, and a peak population of 456 was reached in 1910. (191) 1900

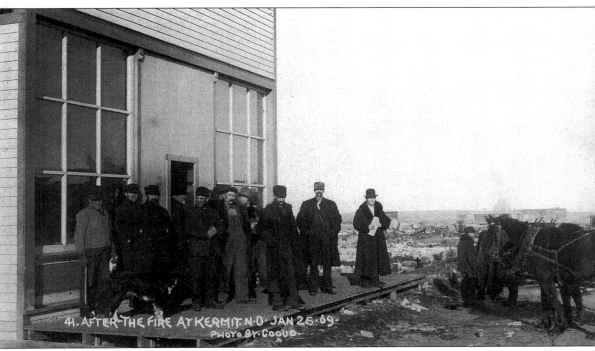

41. AFTER THE FIRE AT KERMIT. N.D. JAN 26·09
PHOTO BY COOUD

KERMIT (Divide). This town site was plotted in 1906, and was named for former president Theodore Roosevelt's son, Kermit, who was killed in France during World War I. The message on this postcard reads: "This card shows the ruins of my hometown. It burned out on January 26, with seven other business places, and I left Kermit the 15th of last month." 1909

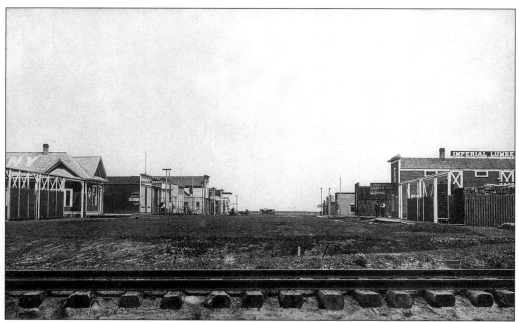

KRAMER (Bottineau). The Soo Line Railroad, after marking their town site, brought in Eastern businessmen to look over these sites and help name them. Kramer was named after a New York importer. As soon as lots were bought in 1904, lumber was hauled from Omemee for the first buildings. By the fall of 1905, Kramer was a busy village with 151 people. (51)

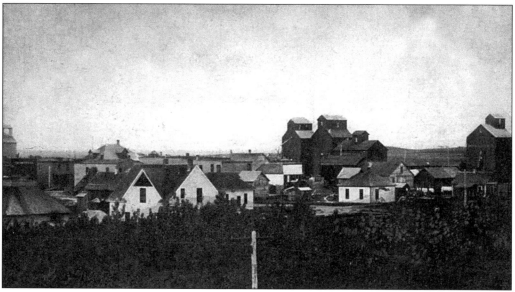

KNOX (Benson). There was no blacksmith shop in town, so the farmers had to pound out any nicks in their plow shares with a hand anvil and hammer. There were no churches in the early 1890s, but a traveling minister would stop now and then to conduct services in the homes. (45)

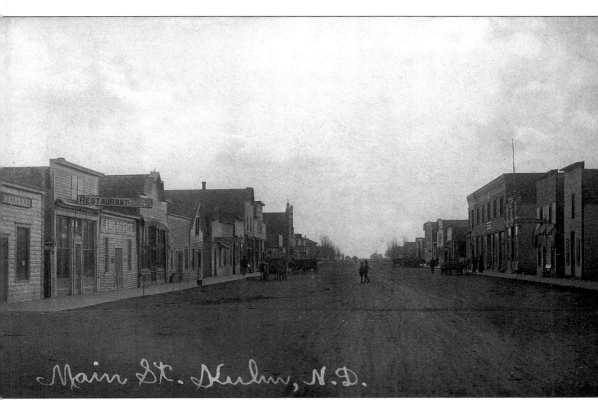

Main St. Kulm, N.D.

KULM (LaMoure). This town site was established in 1892 with many settlers from Kulm, Russia, or Kulm, Germany. When the depot was built and the town sign displayed, Kulm was the decided name. For years the Norwegian and Swedish families kept to the north side of town, and the German community settled south of town. Actress Angie Dickinson was born here in 1936. (514)

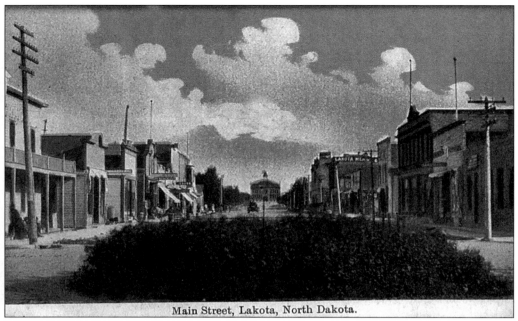

Main Street, Lakota, North Dakota.

LAKOTA (Nelson). Lakota became the county seat in 1883 and incorporated as a village in 1885. During its early years businesses changed quite frequently, but two mercantile companies remained stable for many years. The first restaurant was opened in 1912. (898) 1910

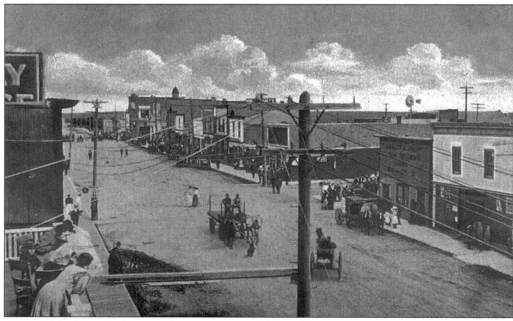

LANGDON (Cavalier). Langdon was named for Robert Bruce Langdon (1826–1895), a Minnesota legislator and official of the Great Northern Railroad, who donated a bell for the school. Langdon is self-proclaimed the "Durum Capital of the World." (2,241)

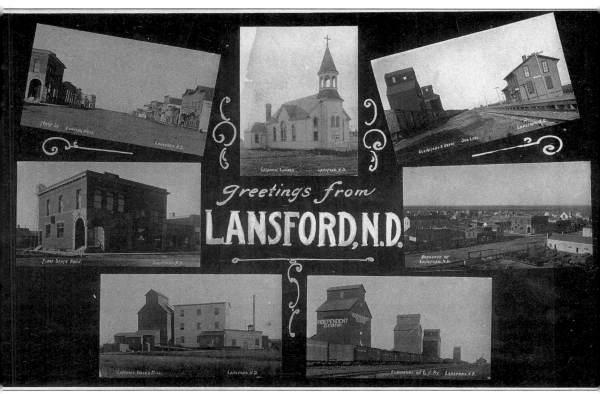

LANSFORD (Bottineau). A young lawyer who arrived in Lansford in 1903 recalls building his new office when a blizzard hit the town on September 12, and lasted for several days. The storm did extensive damage to the crops and livestock, but the snow disappeared in a few days, and they had excellent weather until Christmas. The sloughs were full of water, and there were plenty of ducks for hunting. The message on this postcard reads: "I got my certificate from the May exam, I expect to teach this fall." (249) 1909

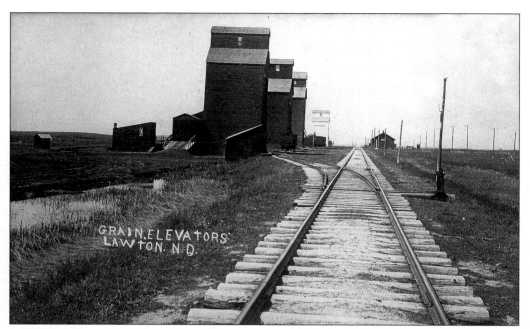

LAWTON (Ramsey). This post office was established in 1899. The Great Northern Railroad reached the site in 1902, and the town incorporated in 1911. A peak population of 233 was recorded in 1930. (63)

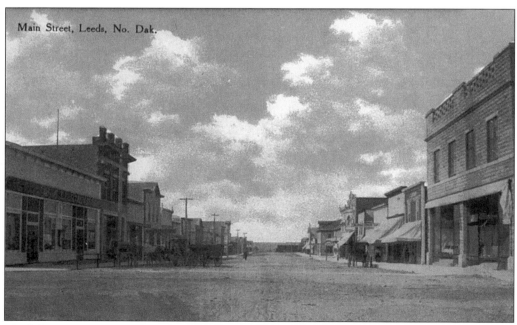

LEEDS (Benson). Apparently, there were no businesses in Leeds when the railroad came through in 1886. Leeds incorporated as a city in 1903 with a population of 589. In 1901, the village marshal was to notify all persons using the streets and alleys as private depositories for manure to remove these nuisances. (542)

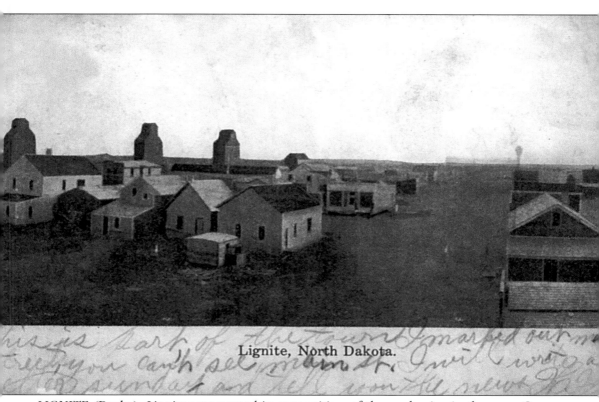

Lignite, North Dakota.

LIGNITE (Burke). Lignite was named in recognition of the coal veins in the area. One of the general merchandise stores was destroyed by fire in 1910, caused by an explosion of the lighting system. At the time there was a small generating plant in the back of the store where the gas was kept. This gas was distributed to gas mantles throughout the store by tiny tubes about an inch in diameter. (242) 1908

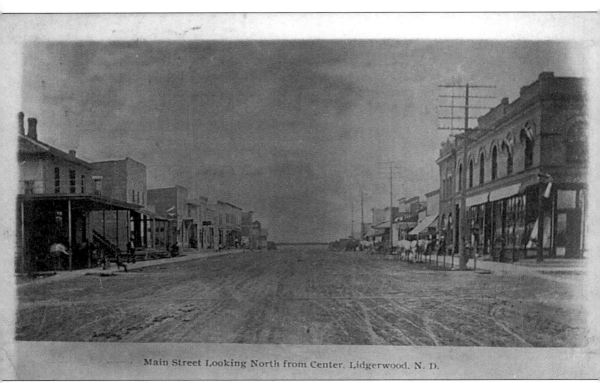

Main Street Looking North from Center, Lidgerwood, N. D.

LIDGERWOOD (Richland). In a 1906 editorial under the heading "A Wide Open Town," the following comments were excerpted: "Last Sunday was a wide-open town for the first time in many years, and the streets were full most of the time with drunken men. But if Sunday was bad, Tuesday was worse—'The Blind Pigs,' of which there were four, were filled. Mayor Maas reported that they took advantage of his absence from the city, and it will not happen again." (799) 1908

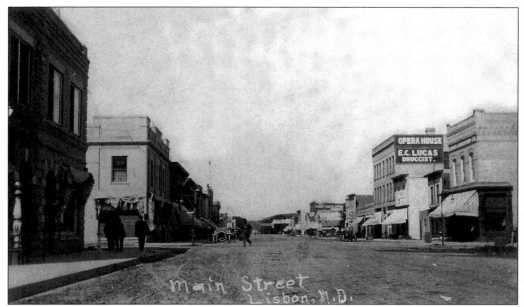

LISBON (Ransom). Because of litigation over the title to land lying between the north and south ends of town, the mid-section was not settled as it would have been otherwise, and when a disastrous fire swept away all the south-end stores, many of the residents left town. The first stock of lumber for the lumber dealer was floated down the Sheyenne River from Valley City in 1882. (2,177)

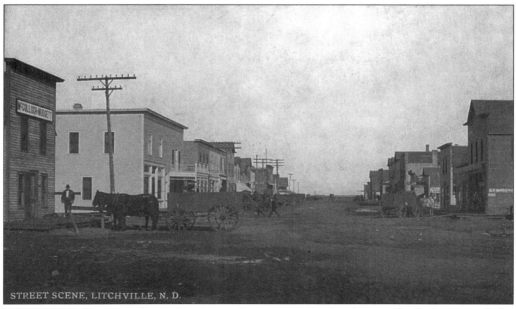

LITCHVILLE (Barnes). In 1901, three elevators and a bank were built here, and the newspaper, *The Litchville Bulletin*, was printed. Fred George Aandahl, governor of North Dakota from 1945 to 1959, was born here in 1897. At one time, Litchville contained five grocery stores, six churches, and two banks. (205)

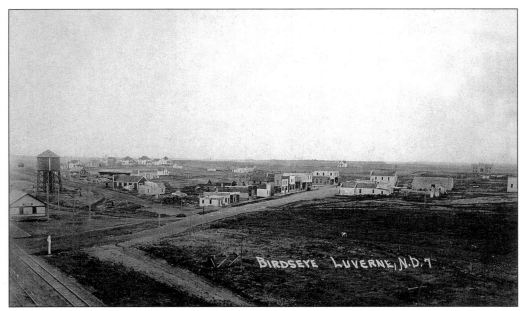

LUVERNE (Steele). Many of the original settlers came here from Denmark. The town site was founded in 1910, and a peak population of 241 was reported in 1920. A prominent feature in the area is the Great Northern Railroad high bridge nearby, which is very similar to the more familiar bridge at Valley City. (41)

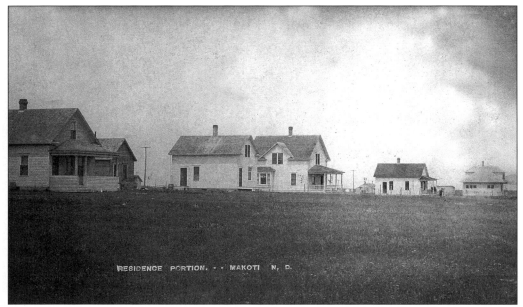

MAKOTI (Ward). An ordinance of Makoti in 1916 read: "No person shall drive or ride horses, automobiles, or motorcycles upon streets or alleys within the city for the purpose of speeding or racing at a greater speed then eight miles per hour." (145)

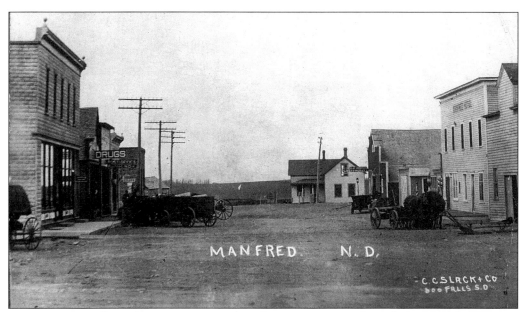

MANFRED (Wells). This Soo Line Railroad town site was founded in 1893 between Harvey and Fessenden. The principle language spoken here was Norwegian—church services were even held in Norwegian. The village never incorporated.

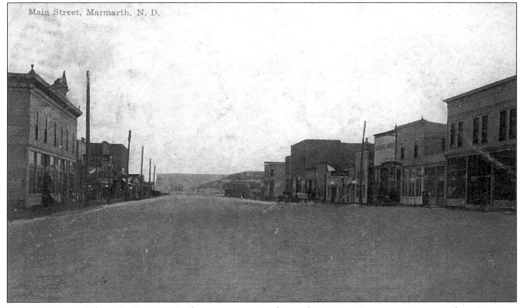

MARMARTH (Slope). In 1922, the carmen and machinist union went on strike. During this time the town stood still, and the railroad took the work that needed to be done to other points. The strikers—65 of them—were never rehired, and the railroad shop closed. From that time on, the town gradually declined. (144) 1912

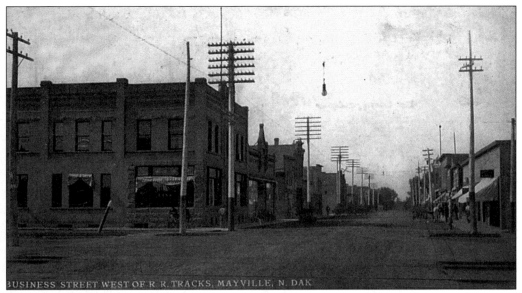

BUSINESS STREET WEST OF R. R. TRACKS, MAYVILLE, N. DAK

MAYVILLE (Trail). Mayville incorporated as a city in 1888. Clarence Norman Brundsdale (1891–1978), governor of North Dakota from 1953 to 1957, was a prominent resident. In 1889, when North Dakota became a state, the state Constitution provided for a Normal School in Mayville, which is now known as Mayville State College. (2,092) 1907

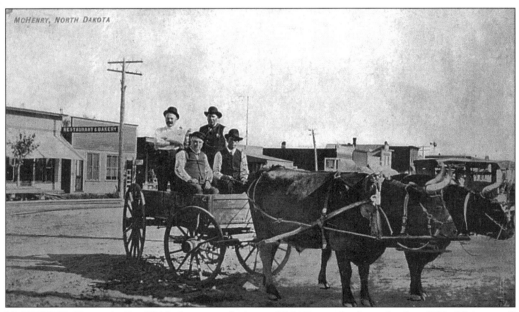

McHENRY, NORTH DAKOTA

McHENRY (Foster). By 1910 the population of McHenry had peaked at 500. This small area boasted four churches, seven grain elevators, and about fifty other businesses before the Depression. The Northern Pacific abandoned its branch line to McHenry in 1981. The unique loop for turnabouts just west of town is now preserved as a National Historical site. (85) 1911

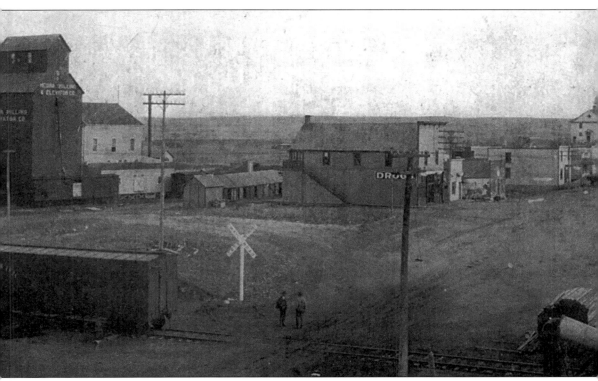

MEDINA (Stutsman). Northern Pacific tracks were laid through Medina in 1872, and the section house and depot were established in 1873. The town was known as the 11th Siding, then Midway, and finally changed to Medina in 1882. From 1905 to 1910, it was known as the "Biggest Little Town on the Northern Pacific." On February 13, 1983, federal marshals attempted to arrest tax protester Gordon Kahl here. Two federal marshals died at the scene. (387)

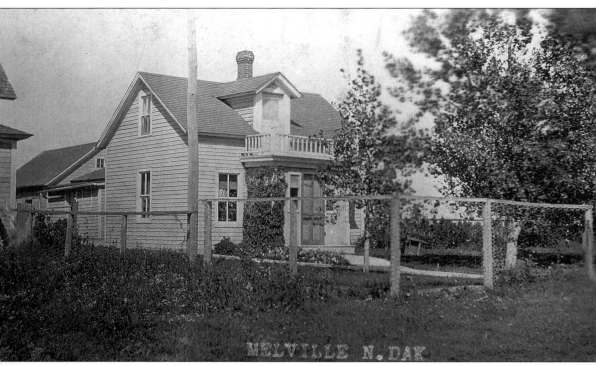

MELVILLE (Foster). This town site originated as Newport in 1883 and was located 1 mile south. However, the railroad company and its owners could not agree on the price of the land, so the company accepted a free site from Lyman R. Casey, who changed the name from Newport to Melville. In 1882, Mr. Fawcett witnessed a 100-pound meteor falling from the sky. The next morning he found the meteor near his house and tried to move it, but it was to hot to handle. A few days later, with help from his friends, he moved it to his yard in Melville.

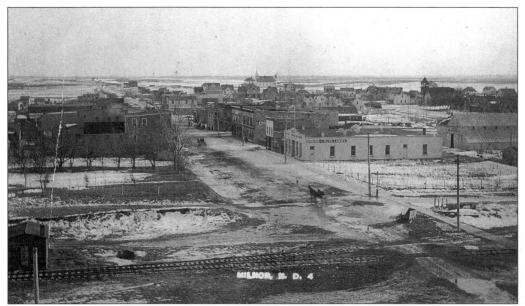

MILNOR (Sargent). This settlement was designated as the county seat in 1883, but lost that honor in 1886 to the centrally-located town of Forman. It contained a college for two years before it was relocated to Mayville. For some time, Milnor has been protected by the oldest rural fire department in the state. It had a population of 850 in 1890. (651)

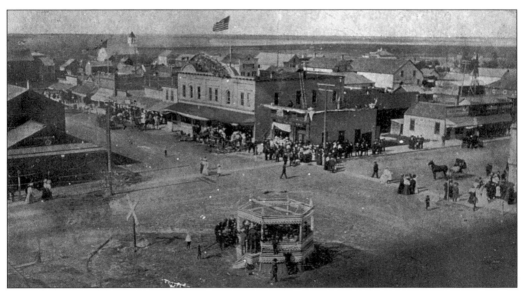

MINNEWAUKAN (Benson). Minnewaukan was founded in 1883 as one of several sites competing for the important Northern Pacific Railroad connection at the west end of Devils Lake. Information from *Dakota Siftings* dated June 7, 1884, states: "John McGowan will cross teams over the big coulee on his ferry at half rates to those on the opposite bank who will do their trading in Minnewaukan." (40) 1909

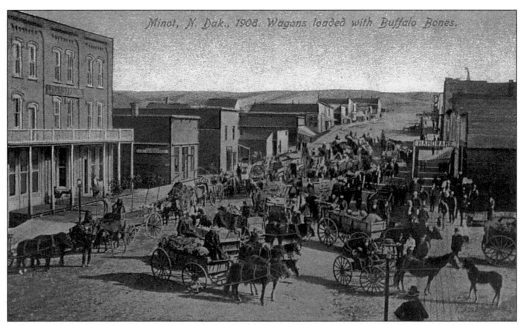

MINOT (Ward). This postcard shows wagons loaded with buffalo bones being brought to Minot to be loaded on the train. They were usually shipped to St. Louis to be pulverized for fertilizing purposes. (34,544) 1908

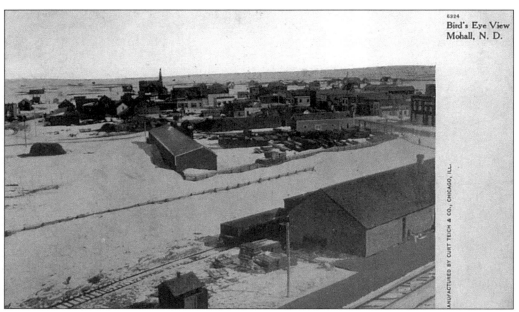

MOHALL (Renville). In 1905, the first public well was sunk in Mohall. A count of business places and offices as the year began showed 125 in existence, as compared with one building in 1901. Thomas H. Moodie, governor of North Dakota, was a longtime resident. (931) 1908

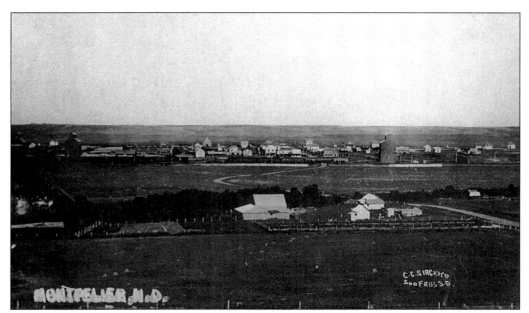

MONTPELIER (Stutsman). This Northern Pacific Railroad town site was plotted in 1885 just north of the old town site of Tarbell, which it absorbed. In 1906, *The Jamestown Daily Alert* ran an article stating that: "Montpelier is growing in businesses and residences. The State Bank is completing a new cement block bank building 24' x 26', with a large vault." (82) 1912

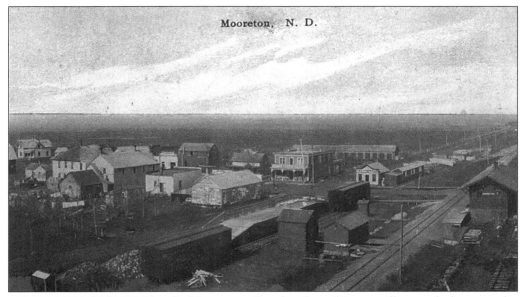

MOORETON CITY (Richland). Mooreton City developed into a village to help serve the Antelope Farm, a 17,300-acre bonanza farm owned by Hugh Moore. *The Wahpeton Farmer Globe* reported in 1942: "The scrap iron drive was a big success at Mooreton—66,335 pounds of iron including one of the oldest automobiles of the county, a single cylinder Cadillac." (193)

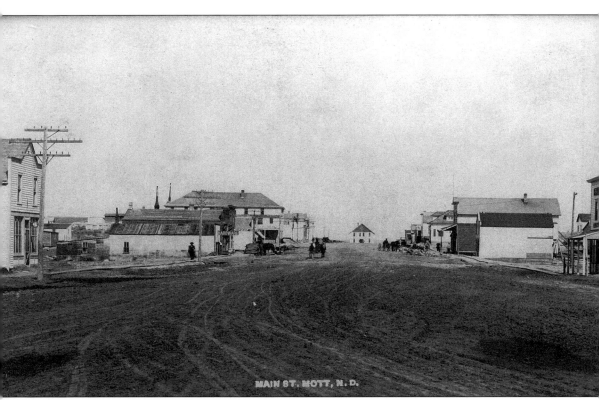

MAIN ST. MOTT, N. D.

MOTT (Hettinger). The Fourth of July celebration in 1906 included a dance and ball game, and many families brought picnic lunches. The river was so high that year that some homesteaders bound for the celebration crossed the Cannon Ball River in a pig trough. (1,109)

Five
NECHE TO RYDER

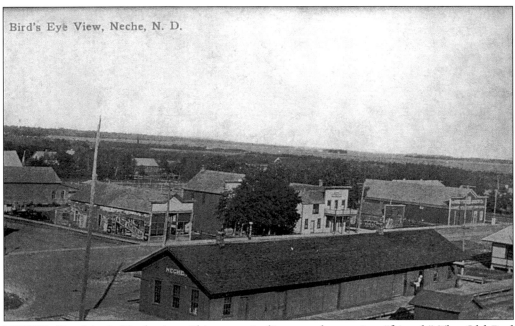

NECHE (Pembina). Neche is a Chippewa Indian word meaning "friend." The Old Red Hall was built in 1900 with the only tilting floor in the world, according to *Ripley's, Believe it or Not*. William L. Walton manufactured automobiles here from 1902 to 1906. (434) 1915

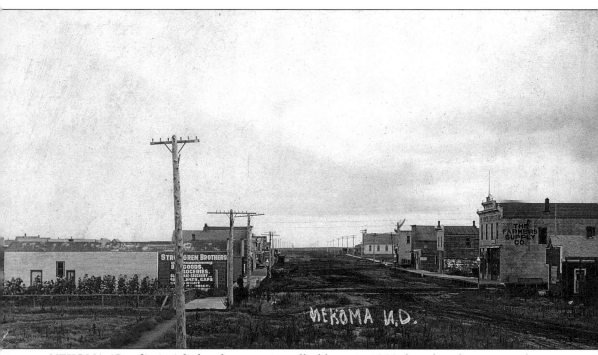

NEKOMA (Cavalier). A light plant was installed here in 1920, but the plant was only run during certain hours. The city engineer was instructed to run it on Monday and Tuesday mornings and also on special late-night occasions. A "blink-blink" warning signaled patrons to expect a blackout within a few minutes. The country's only Safeguard ABM and Missile Site Radar military installation are located northeast of town. (63) 1910

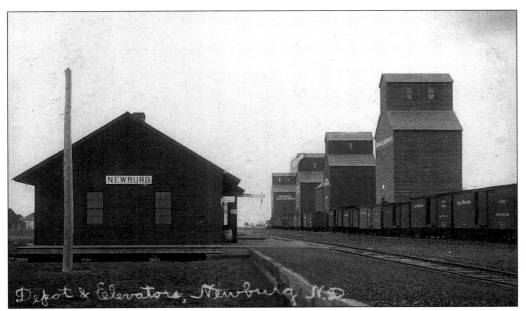

Depot & Elevators, Newburg N.D.

NEWBURG (Bottineau). This Great Northern Railroad station was founded in 1905. It once had four elevators, two lumber yards, two hotels, two banks, and various other businesses. The message on this card states: "Show work is tiresome to me, but tonight I shall write you anyway." (104) 1910

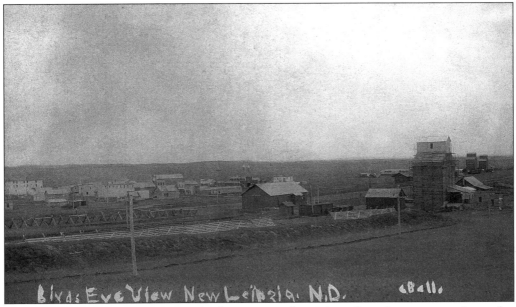

Blrds Eve View New Leipzig. N.D.

NEW LEIPZIG (Grant). Leipzig had a spurt of activity after the construction of a Farmer's Creamery in 1901. After that it grew steadily, reaching its peak in 1909. By 1910, when the Western Dakota Company survey crews staked out the line about 8 miles south of Leipzig, most of the residents decided to move to the new town site, which was called New Leipzig. (326)

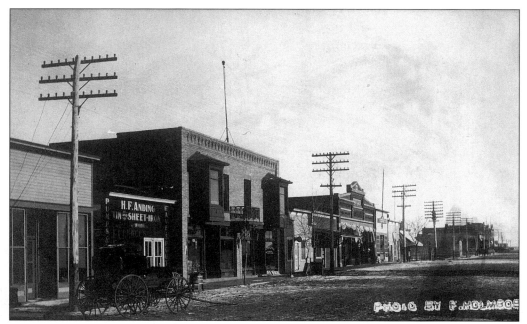

NEW SALEM (Morton). The first settlers here were German Lutherans sponsored by a church group in Chicago, and the second wave of settlers were German Nationals from Worms, Rohrbach District, South Russia. To pay tribute to its dairy industry, the city built the world's largest holstein cow on a butte just north of town. (909) 1907

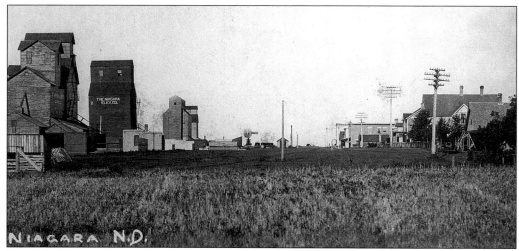

NIAGARA (Grand Forks). Niagara had a peak population of 207 in 1930. The first building in town contained a general store and post office. The Pillsbury and Hubert Elevator Company built the first elevator here in 1883. Their first power to handle grain was provided by a team of blind horses. Grain was hauled to the elevator in sacks. 1907

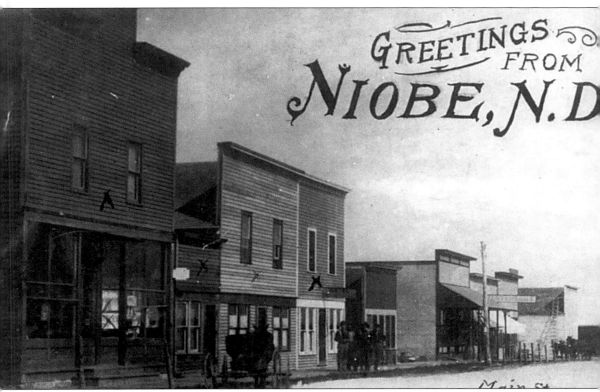

GREETINGS FROM NIOBE, N. D

NIOBE (Ward). Niobe is situated on a flat piece of prairie with a small coulee to the northwest. In 1907, only 18 of the 122 lots were sold. The nationality of the residents was predominantly Swedish. In 1908, a lumber fence was built around the lumberyard, which was noteworthy enough to merit printing in the Kenmare newspaper. The message on this postcard reads: "I will drop you a card so you can see what went up in smoke. I made an X on each one." 1912

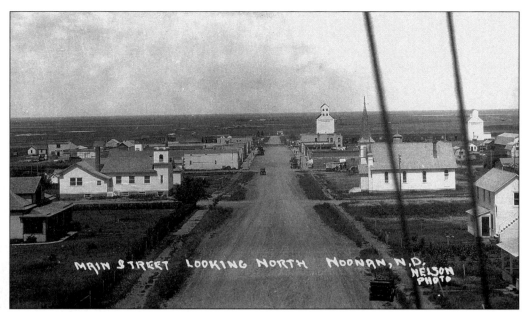

NOONAN (Divide). Noonan was named for the Noonan family who had business, farm, and coal interests in the area. It once was known as. "The White City" because of an ordinance requiring all buildings to be painted white. (231)

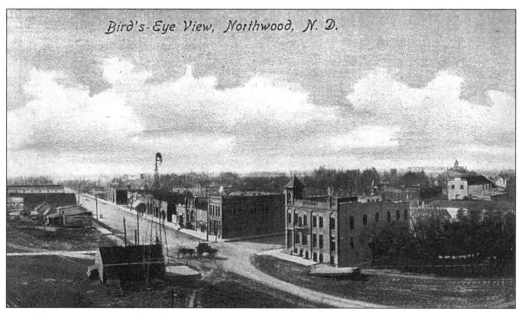

NORTHWOOD (Grand Forks). In 1899, an explosion occurred when a employee used benzene to exterminate bed bugs in one of the rooms in the National Hotel, then lit a lamp to curl her hair. Fifty business places and residences were destroyed in the flames. (1,166) 1900

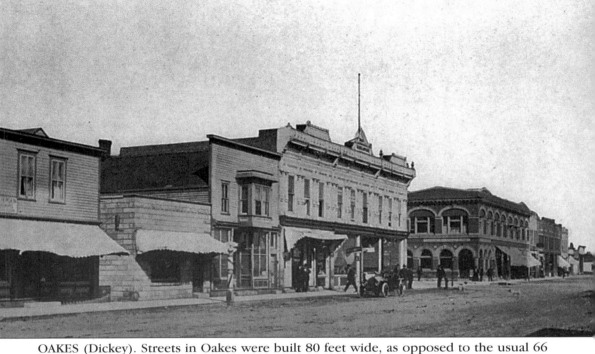

OAKES (Dickey). Streets in Oakes were built 80 feet wide, as opposed to the usual 66 feet. All east-west streets—except for Union Street—were given the name of a tree. The greatest business enterprise in Oakes was the North American Creamery Company, which was built in 1904. They bought cream, made butter, and handled eggs—proving that there was a real opportunity in butter-making in North Dakota. (1,775)

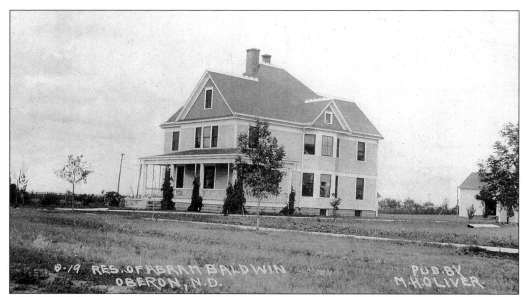

OBERON (Benson). By 1892, seven new buildings had been constructed—a livery and feed, hotel, lumberyard, and a store with a temperance hall. This postcard shows the residence of Abram Baldwin, who married Belle Whitcomb in 1891. Belle came here from Pullman, Illinois, with her parents. (103) 1914

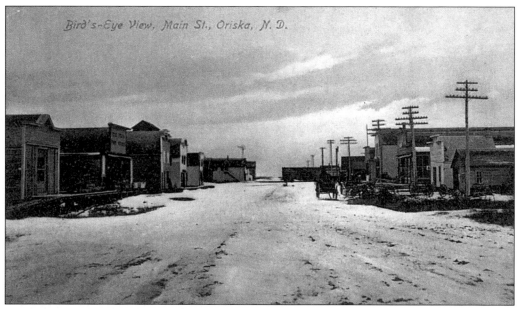

ORISKA (Barnes). Oriska was founded in 1872 as Fourth Siding on the Northern Pacific Railroad mainline, and was renamed Cagton in 1879. The name was finally changed to Oriska in 1881. The oldest known photograph on Main Street is this one taken April 9, 1904. The buildings, from left to right, are: the Ottiner Store, Jordan house, Northern Pacific Depot, Wegner Store, Dean Smith's building, Gauche store, and Gamble's Blacksmith Shop. (103)

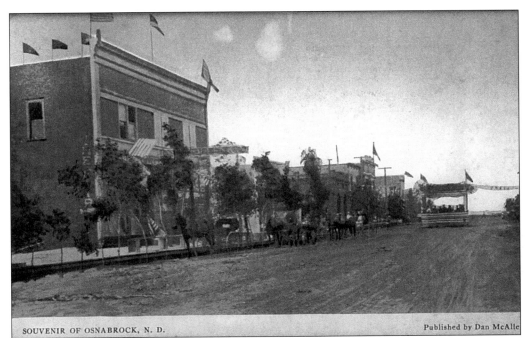

SOUVENIR OF OSNABROCK, N. D. Published by Dan McAlle

OSNABROCK (Cavalier). Early church services were held at the town hall. Woodman Hall was heated by an old wood stove and lighted with kerosene oil lamps. It contained a makeshift stage of planks laid on saw horses. The stage curtains of black muslin or calico were strung on tight wires and were opened and closed by hand. (214) 1908

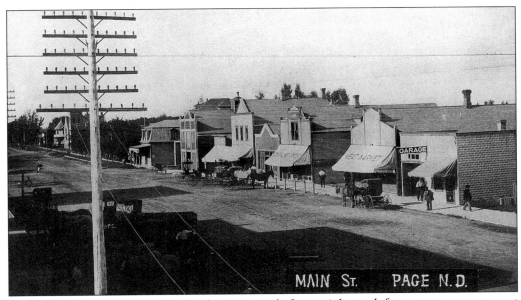

MAIN St. PAGE N.D.

PAGE (Cass). The buildings on this postcard, from right to left, are: a garage, meat market, and a general merchandise store. Louis B. Hannah (1861–1948), a U.S. representative and governor of North Dakota, was a longtime merchant and banker here. (266)

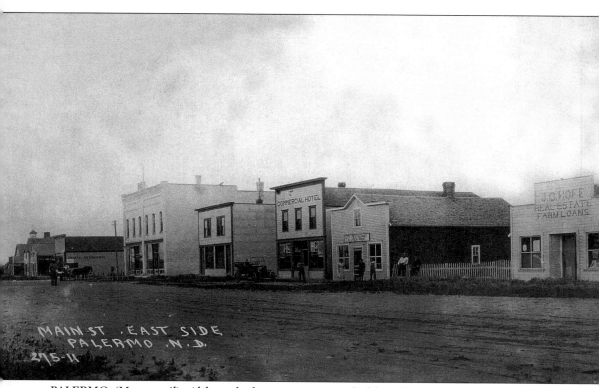

PALERMO (Mountrail). Although the town was settled largely by people of Norwegian ancestry, it was named for the capital of Sicily to honor Italians who had worked on the railroad in the area. The population peaked at 205 in 1930. (95)

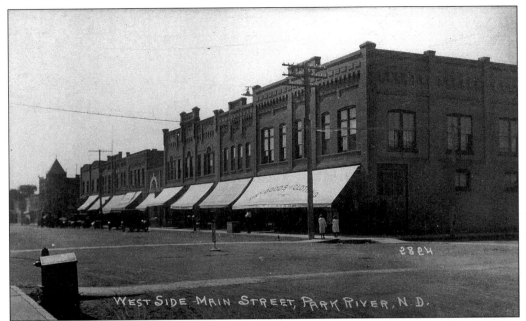

WEST SIDE MAIN STREET, PARK RIVER, N.D.

PARK RIVER (Walsh). Park River was named for its location on the Park River. Records show that in 1901, it had a population between 1,400 and 1,500. The Park River trade territory had unlimited horizons to the west. Samuel Holland (1859–1937), manufactured automobiles in Park River. (2,725)

PEMBINA (Pembina). The Northwest Airlines dedication was held here in 1931. A large crowd was expected, which produced a water shortage. As a result, stones were hauled in, and a crib dam was built on the Pembina River, which washed out in 1932. A permanent dam was constructed in 1934 by free WPA labor. (642)

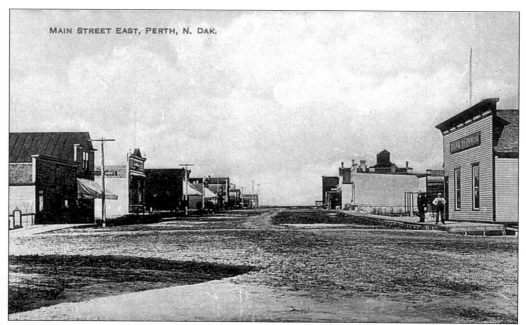

MAIN STREET EAST, PERTH, N. DAK.

PERTH (Towner). Perth was named for Perth, Ontario, Canada, the former home of Robert J. Laird, the town site owner and postmaster of the earlier post office that had been established in his home in 1899. Perth reached a peak population of 221 in 1910. (22)

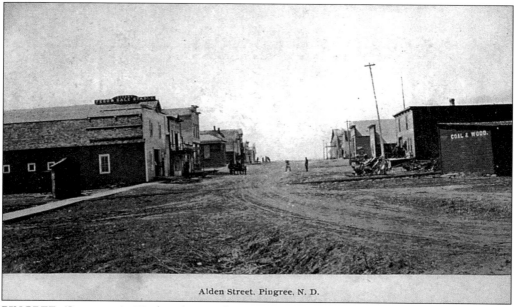

Alden Street, Pingree, N. D.

PINGREE (Stutsman). Under the Timber Act, which was passed in 1873, modified in 1878, and repeated in 1891, a settler could acquire 160 acres of land by filing on it and paying the $14 fee, then planting 10 acres of trees. This helped to develop the scenery of the area with the many half-mile-long tree claims that we still see today. (61)

84

Birdseye view of Plaza, N. D.

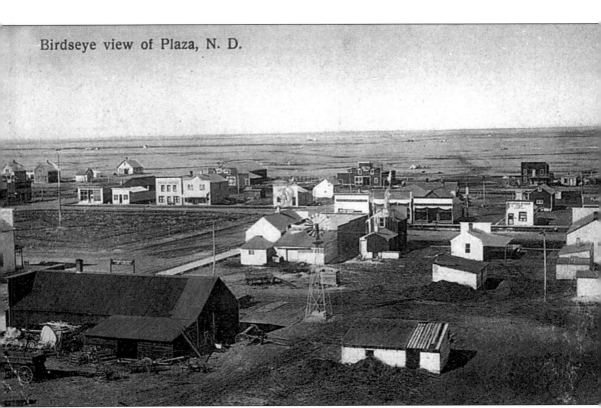

PLAZA (Mountrail). Plaza was named in honor of the central plaza within the business district. The first school in Plaza was held in the upstairs of the Old Pioneer Building. The attendance of the school was not as large as many rural schools of that day, and the length of the term was three months. The first teacher earned a salary of $50 a month. (193)

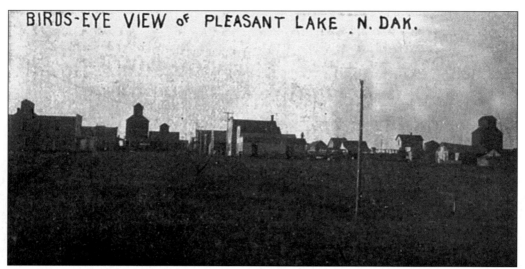

BIRDS-EYE VIEW of PLEASANT LAKE N. DAK.

PLEASANT LAKE (Benson). Local Indians had called it Broken Bone Lake because they used the site for slaughtering buffalo. The Pleasant Lake hills have the largest collection of Indian artifacts in the area. The town reached its peak population of 100 in 1920. 1910

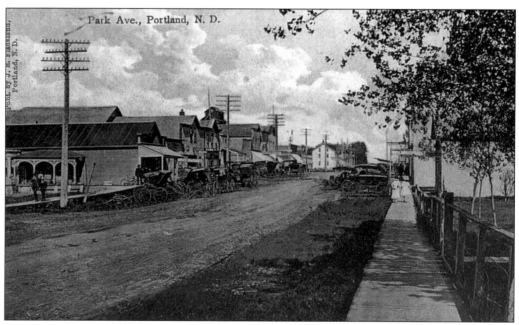

Park Ave., Portland, N. D.

PORTLAND (Trail). The name of Portland is thought to recognize the fact that railroad officials believed this to be halfway between Portland, Maine, and Portland, Oregon. The Farmers Mutual Insurance Company of Trail County received its charter on June 22, 1885, the first such company organized in Dakota Territory. The first policy was $100 for a house and $300 for a horse. (602)

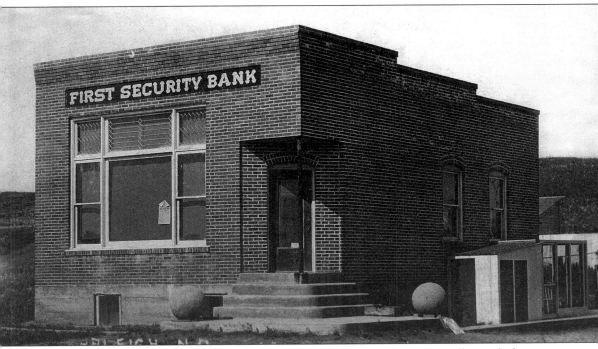

RALEIGH (Grant). A group of Germans from Russia who had originally settled near Strausburg moved here. This postcard is the First Security Bank in Raleigh. The message on it reads: "The two large balls of stone in front of the bank are stones found just like that about ten miles from here. That is the natural shape." 1914

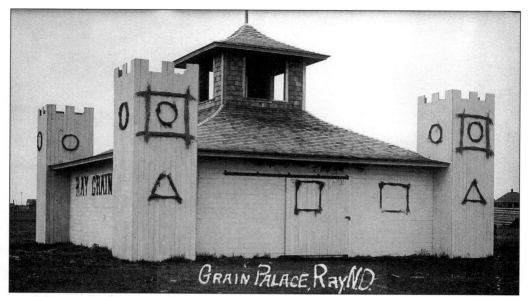

RAY (Williams). In 1906, Ray won the North Dakota State Basketball Championship. The Commercial Club sponsored the construction of the Grain Palace in 1911 with donations from the community, with primarily farmers financing the project. The building was 25 feet square. (603)

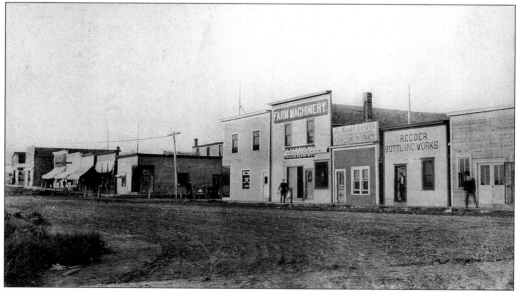

REEDER (Adams) In 1908, the auditorium, complete with gasoline lighting, was built by the baseball team with proceeds from their games and dances. Church services were held in a schoolhouse north of Reeder and later in the hall above the Mercantile store. Services were held in Norwegian and English. (252)

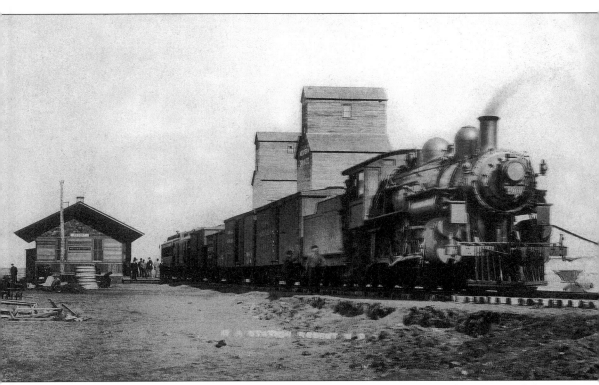

REGENT (Hettinger). On April 15, 1910, Hershel James published the first issue of the *Regent Times*, with the following introduction: "The publisher has no promise to make, beyond that it shall be our aim to publish a live, spicy, local newspaper that will represent Regent, the wonder city on the Milwaukee Railroad in central Hettinger County." Senator Byron Dorgan was born here. (268)

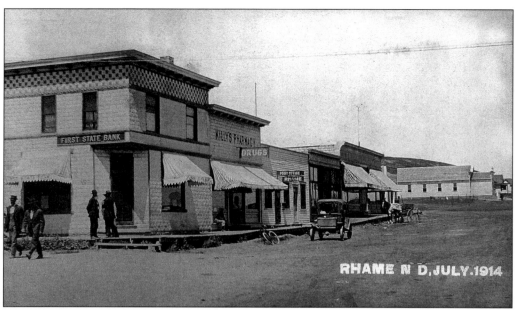

RHAME (Bowman). This establishment was originally known as Detrel and then changed to Rhame in 1908. During the district basketball tournaments, which were usually held in Hettinger, someone phoned the period scores of Rhame to the drug store, which was filled with anxious fans. (186) 1915

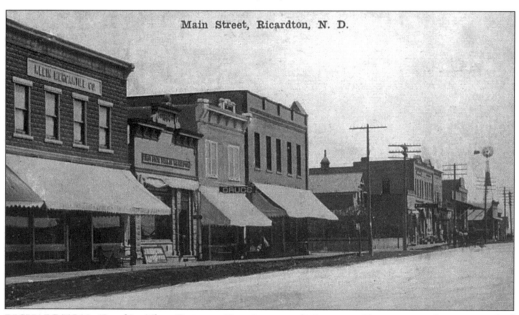

RICHARDTON (Stark). The German-Russians and German-Hungarians homesteaded near here. In 1899, Father Vincent Wehrle built the Benedictine Monastery of St. Mary's (now known as Assumption Abbey) and soon had a school for young men. The Abbey Church, completed in 1908, became widely known as the Cathedral of the Prairies. (625)

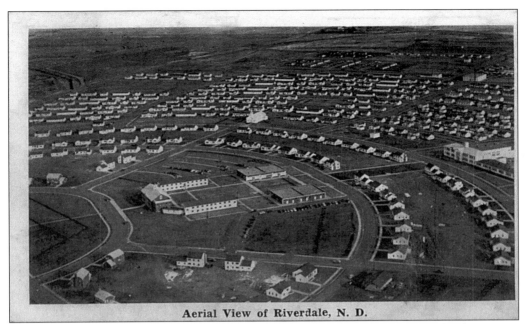

Aerial View of Riverdale, N. D.

RIVERDALE (McLean). The United States Army Corps of Engineers released information in 1945 for a "Dam City" to house approximately 8,000 workers who were to be employed during the construction of the yet-to-be funded Garrison Dam. The name Riverdale was selected from a list of 20,000 entries, which had been submitted to 24 participating newspapers in a "name the town" contest. (283)

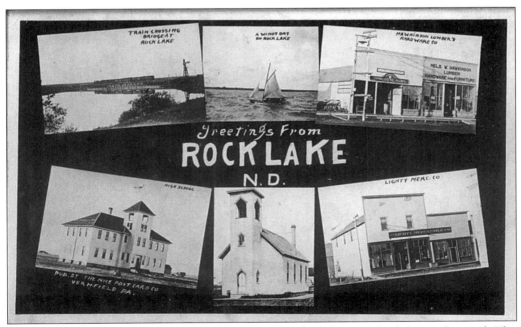

ROCK LAKE (Towner). Rock Lake was named for the lake on which it was located. The official name is Rocklake, but nearly all maps use the two-word spelling. (221)

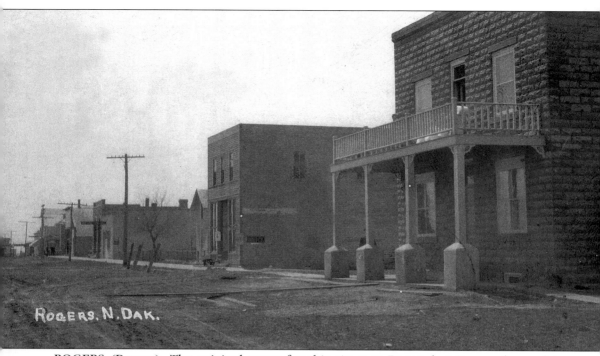

ROGERS (Barnes). The original name for this site was Roger, but it was changed to Rogers on July 13, 1917. It incorporated as a village in 1915. (69) 1914

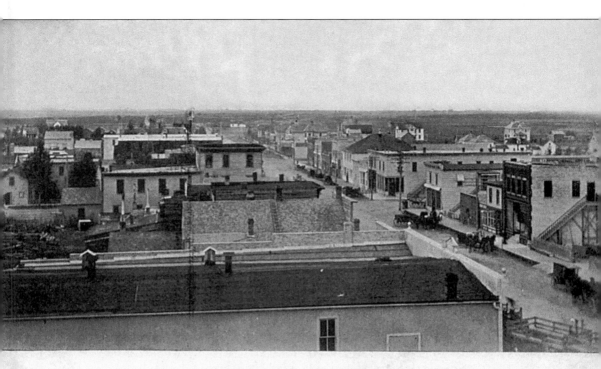

Main Street, City of Rolla, N. D.

ROLLA (Rolette). Rolla bills itself as the "Jewel City of America." One of the characters of the town who was especially interesting to the children was Chang, the Chinese laundry man. His antics fascinated them. He would fill his mouth full of water and then sprinkle the water on the laundry to be ironed through his teeth—a performance that Chang seemed to enjoy as much as the children. (1,286)

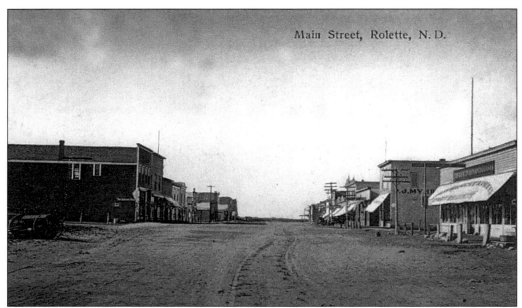

Main Street, Rolette, N. D.

ROLETTE (Rolette). McCumber and Rolette were only a mile apart. A schoolhouse had been built not far from either town, but both towns wanted the school within its borders. Following a bitter dispute about the school issue, several young men went out one night, jacked up the small structure, and quietly moved it into Rolette. (623)

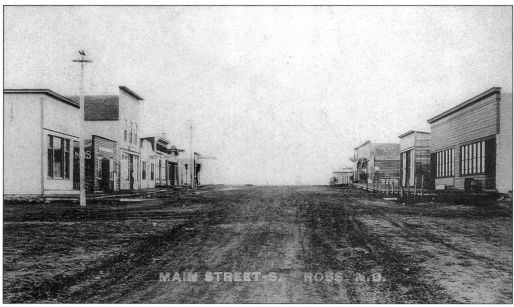

MAIN STREET-S. ROSS. N.D.

ROSS (Mountrail). Among the early settlers were immigrants from Syria, and their mosque, built in 1930, is considered to be the first Moslem house of worship in the United States. Ruth Olson Meiers, the first female lieutenant governor of North Dakota, was a resident here. (61) 1910

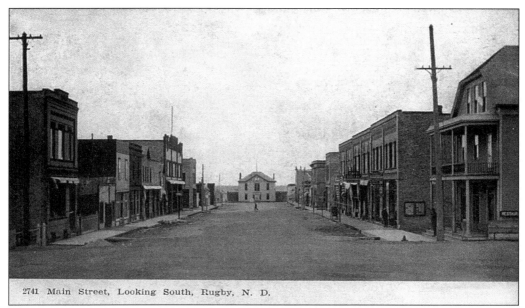

2741 Main Street, Looking South, Rugby, N. D.

RUGBY (Pierce) The town was plotted as Rugby Junction in 1886. Before this, a village plot had been started about 80 rods east of Main Avenue in Rugby. As soon as the plot of Rugby Junction was recorded and the lots offered for sale, the original village disappeared, and the business houses erected in it were hauled to new locations (2,909)

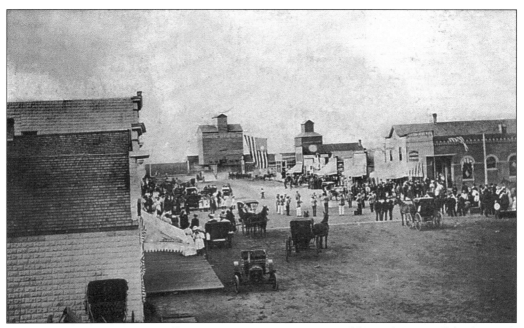

RUSSELL (Bottineau). Russell is a Latin name meaning "red-haired." Russell had a peak population of 161 in 1910. At one time, it had 2 banks, a newspaper, and other businesses. (14) 1908

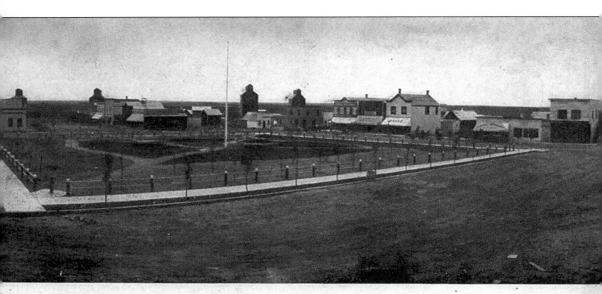

Park in Ryder, N. D.

RYDER (Ward) On a flax field in 1906, the sale of town lots for Ryder began. The big event was highlighted by the spirited bidding of H.C. Miller and Aug. Peterson for the corner lot, which Mr. Miller won for the First State Bank. Mr. Peterson purchased the lot across the street for the First National Bank. All the money bid over the set price went into a park fund for the city, which is why Ryder has such a fine park. (121)

Six

SANBORN TO VOLTAIRE

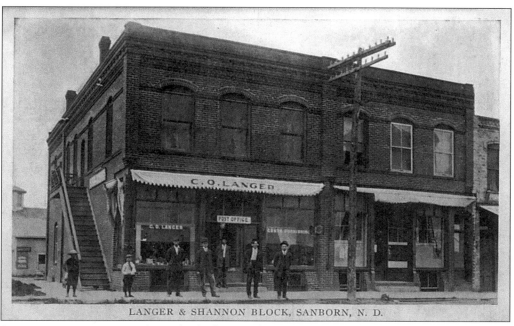

LANGER & SHANNON BLOCK, SANBORN, N. D.

SANBORN (Barnes). Sanborn had plans to become the county seat in the early 1880s but could never get enough votes to make it happen. The school was built here in 1882. A land agent had an interest in the bank as well as the land. He later ran for the position of county treasurer, but after elected, absconded with all the county funds. (164)

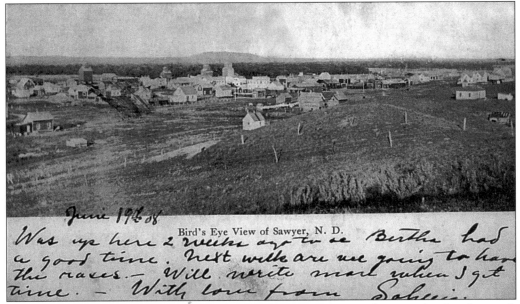

June 19 '08

Was up here 2 weeks ago to see Bertha had a good time. Next week are we going to have the races. — Will write more when I get time. — With love from Sabri....

Bird's Eye View of Sawyer, N. D.

SAWYER (Ward). In 1902, P.H. Podhola came to Sawyer and opened a lumberyard. After that, the town sprang up like a mushroom. There were no churches here yet, and a 1904 funeral was held on Main Street, with the minister preaching from a small platform built on the street while the mourners were standing nearby. (319)

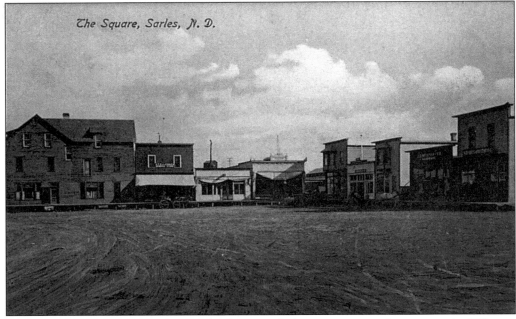

The Square, Sarles, N. D.

SARLES (Cavalier and Towner). The layout of the town around a square is different than most of the towns in North Dakota. Most of the settlers came from England and Scotland, and this was the design they preferred. The business places and residential dwellings surround the square. (86)

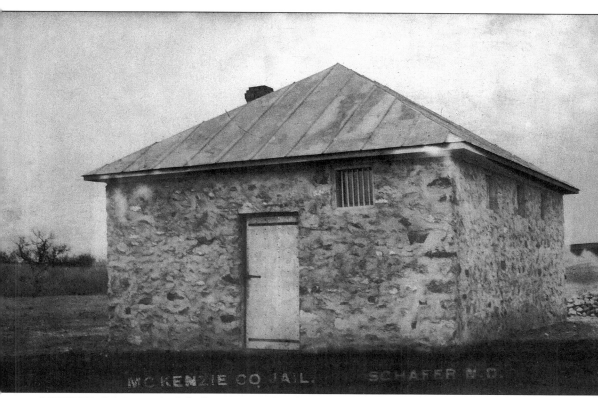

MC KENZIE CO JAIL. SCHAFER N.D.

SCHAFER (McKenzie). Schafer was involved in the battle for county seat from 1905 to 1906, capturing the honor from Alexander. Eventually the county seat was moved to Watford City, and Schafer soon became a ghost town. This message reads: "Where my first client landed after the remedies of the law had been exhausted. How would you like to be a client of mine?" 1912

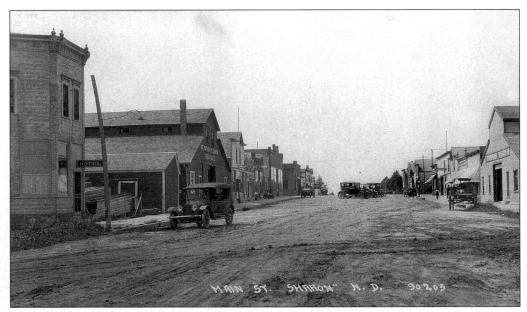

SHARON (Steele). In 1924, the Steele County *Farmers Press* reported the worst fire in the history of Sharon. Lost in the fire were the Kadry Building, the barbershop, the St. Anthony, and Dakota lumberyards—including the coal sheds and lime and cement houses. Losses were estimated at $3,000. The origin of the fire is unknown. (119)

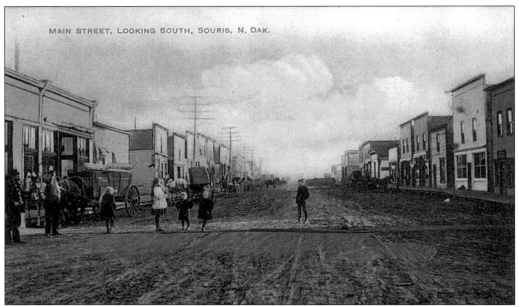

SOURIS (Bottineau). At one time in history Souris had three banks, seven lawyers, three hotels, two doctors, a newspaper, and a total of 55 business establishments. (97)

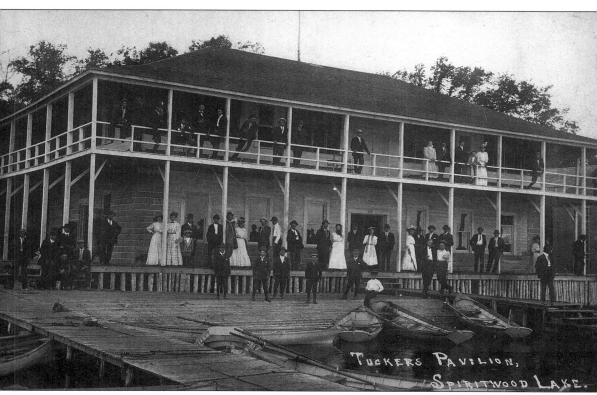

TUCKERS PAVILION, SPIRITWOOD LAKE.

SPIRITWOOD LAKE (Stutsman). The town of Spiritwood Lake was incorporated in 1975 on the south shore of Spiritwood Lake. The area was a resort community in territorial days, originally called Gray and later Community. Many residents live here on a permanent basis.

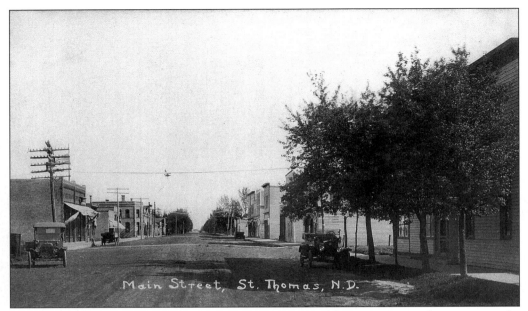

ST. THOMAS (Pembina). The post office was opened here in 1881. The Minneapolis and Manitoba Railroad arrived in 1882. St. Thomas was the largest grain shipping point in the world with 14 elevators. Edward K. Thompson, one-time editor of *Life* magazine and founder of *The Smithsonian* magazine, was a native son. (444)

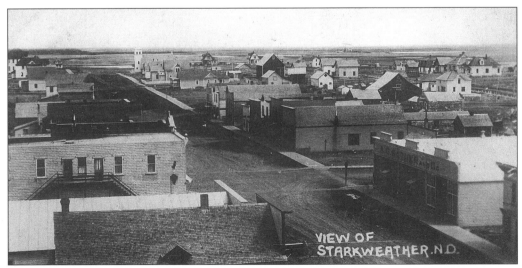

STARKWEATHER (Ramsey). Dr. William Croszier Fawcett, M.D. established his practice in Starkweather and continued to offer its people medical services for the next 41 years. The highlight of the founding of the town was the construction of the Farmer's Railroad Line in 1902. The town contained a busy depot equipped with telegraph services. (197) 1910

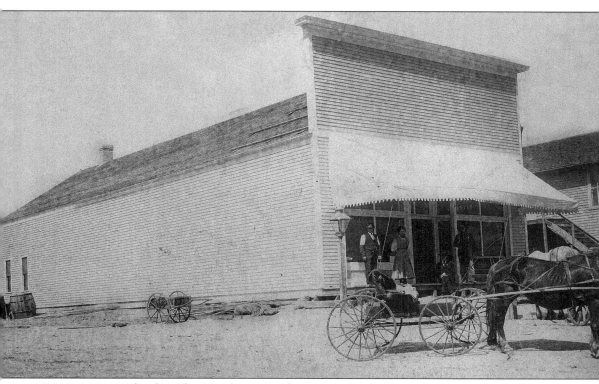

STERLING (Burleigh). The Northern Pacific Railroad siding, constructed in 1893, was first named Sixteenth Siding but was changed to Sterling in 1892. S.T. Parke came here in 1902 as the depot agent, and stayed to take part in many business and town improvements, becoming the postmaster in 1902. According to several advertisements in the 1908 *Sterling Star*, S.T. Parke was a dealer in general merchandise, furniture, and farm machinery. This postcard shows the new Parkes Store.

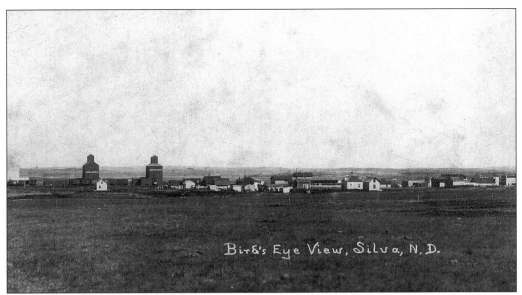

SILVA (Pierce). The post office opened here on June 9, 1913, and a peak population of 125 was reached in 1920. Native son Julius Thompson, who died in 1955, was billed as the "World's Tallest Man," measuring 8 feet, 7 inches, and weighing 460 pounds.

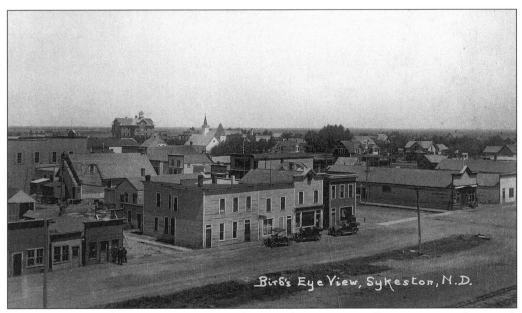

SYKESTON (Wells). Sykeston was the first settlement in Wells County, with a peak population of 367 in 1920. Lake Hiawatha, created here in 1899, is considered to be the first artificial lake in North Dakota. (167)

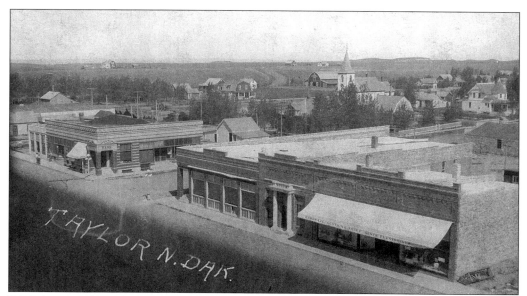

TAYLOR (Stark). This station was originally named Antelope, named for the prong-horned animal that inhabited the area when it was designated in 1881. The name was changed to Taylor in 1882. A point of interest is a buffalo jump 4 miles south of Taylor, where the Indians would drive the animals over a bluff during the hunt. Many artifacts have been gathered at this site. (163)

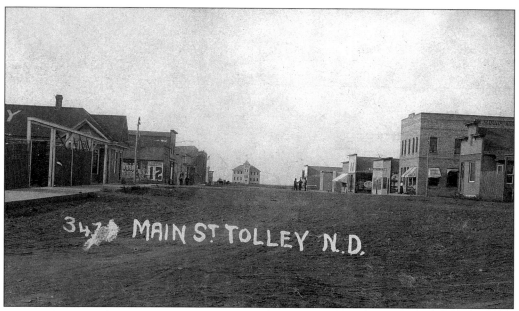

TOLLEY (Renville). Tolley became a permanent fixture in 1905, and it soon had seven elevators, two general stores, a drugstore, a doctor's office, a hospital, two banks, a real estate office, two lumberyards, a printing shop, a barber shop, restaurants, a bakery, a central telephone office, a hardware store, two dray lines, a livery barn, and a hotel. (79) 1909

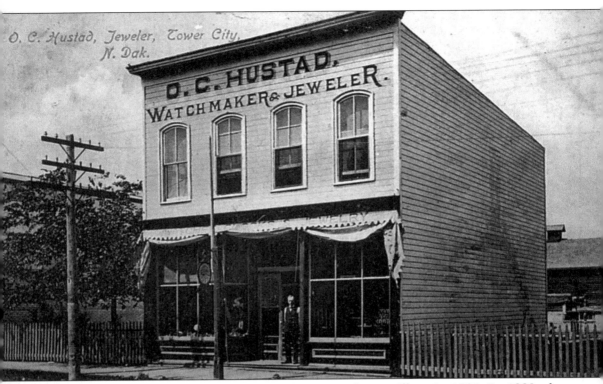

O. C. Hustad, Jeweler, Tower City, N. Dak.

TOWER CITY (Cass). Tower City was incorporated as a village in 1881. In 1883, the town consisted of three churches, a school, two hotels, a bank, a newspaper, a steam elevator, a bed spring factory, and the Tower City Milling Company. The Baptist church operated Tower University here from 1886 to 1888. (233)

chool House, Trenton, N. D.

TRENTON (Williams). With the termination of the Fort Buford Military Reservation, the Trenton valley was open for homesteading. One of the outstanding landmarks of the township is the high bluff about 2 miles east of Trenton, known by everyone as "The Square Mound." It stands separate from the other bluffs, and its base covers about 40 acres. It is about 200 feet high and, when viewed from a distance, it has a pyramid shape. The Great Northern Railroad station was founded in 1894 and named to honor stockholders from Trenton, New Jersey.

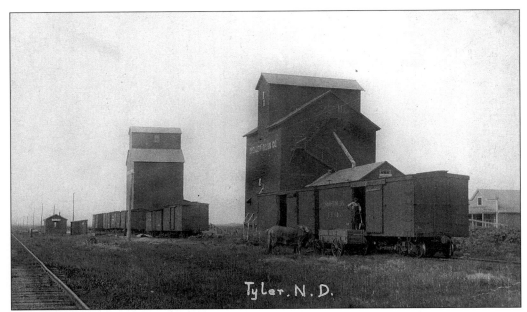

TYLER (Richland). Richard S. Tyler of Fargo purchased and plotted this town site in 1884. Mr. Tyler developed the site into a trading and shipping post, and thus the village of Tyler was born. The post office and store were established in 1891. The town also contained public stockyards, a blacksmith shop, a dance hall, and a general store at one time.

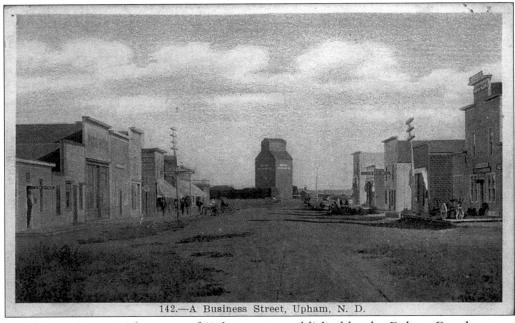

142.—A Business Street, Upham, N. D.

UPHAM (McHenry). The town of Upham was established by the Dakota Development Company in 1905, and the State Bank of Upham was established that same year. The capital stock and surplus of the institution was $15,000. (205)

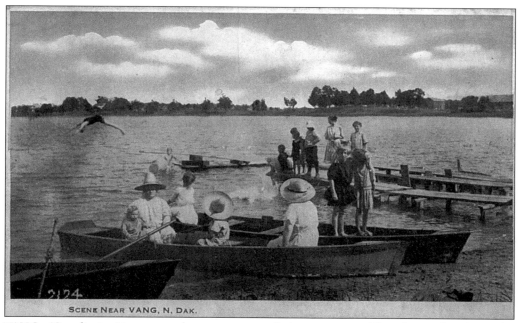

SCENE NEAR VANG, N, DAK.

VANG (Cavalier). Vang was known as a religious center. The first school in the neighborhood was built of logs near the post office in the 1880s with the help of members of the United Lutheran Congregation, who occasionally used the school for church services. This town disappeared from the maps in the 1960s.

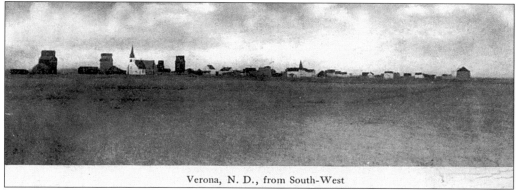

Verona, N. D., from South-West

VERONA (Lamoure). Verona was known as Matson until 1883, when the post office was established and the name changed to Verona. Among the first buildings was a blacksmith shop, where the first wedding in Verona occurred in 1886. A unique situation existed from 1907 to 1911, when this small town had three newspapers competing with each other. (103) 1908

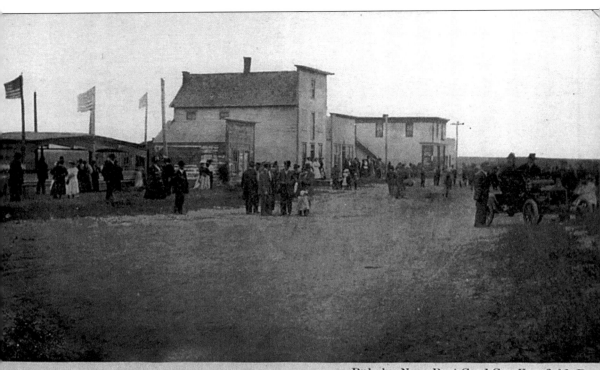

VOLTAIRE, NO. DAK.

Pub. by Nyce Post Card Co., Vernfield, Pa.

VOLTAIRE (McHenry). Voltaire incorporated as a village in 1927. It was a small town consisting of a general store, a hardware store, two elevators, a hotel, a schoolhouse, and a bank. (63)

Seven

WALCOTT TO ZAP

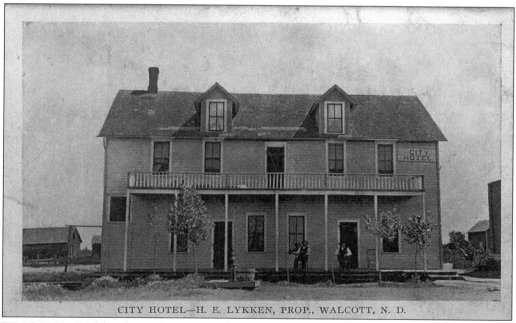

CITY HOTEL—H. E. LYKKEN, PROP., WALCOTT, N. D.

WALCOTT (Richland) Walcott was founded in 1880 by Frank E. Walcott. Three elevators stood side by side along the railroad right-of-way during the early years. In 1913, the middle elevator was struck by lightning and burned. Heavy rain prevented serious damage to other structures but could not save the elevator, which was never rebuilt. (178)

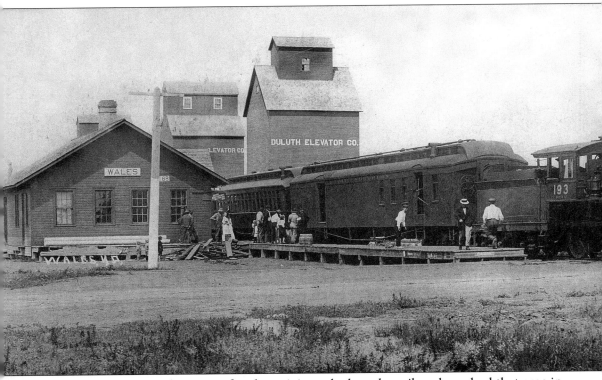

WALES (Cavalier). The town of Wales originated when the railroad reached that area in 1897. An early post office was established the same year, and it was given the name of Rush Lake. The name was changed to Wales in 1899 to please the British railroad stockholders. The mail was brought to Wales at 2 p.m. and then went on to Hannah from there. The train turned around there and picked up the outgoing mail on its way back to Grand Forks. (48)

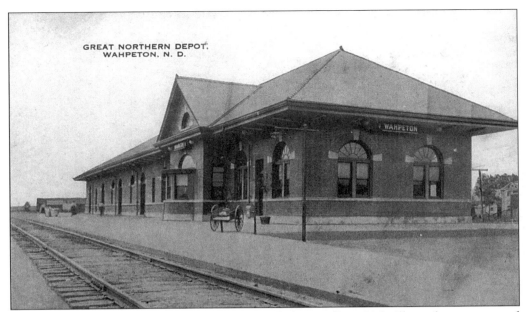

WAHPETON (Richland). Wahpeton was founded in 1869 as Richville and was renamed Chahinkapa in 1873. The current name was adopted in 1875. Highly collected Rosemeade pottery was made here from 1940 to 1956. Steve Myhra, a professional football player, was born here in 1934. (8,751)

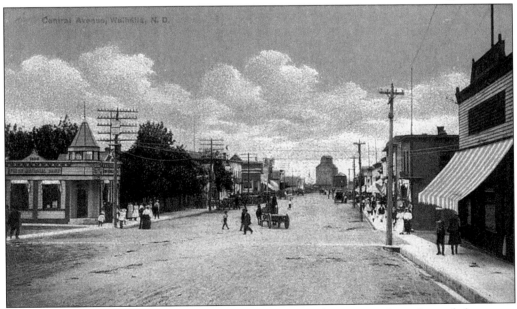

WALHALLA (Pembina). This town was founded in 1840 as Saint Joseph, and the name was changed to Walhalla in 1871. Father G.A. Belcourt built a log church and school here in 1845. Two bells were suspended from a cottonwood tree in 1853, and one of these bells still rings from the belfry of the Catholic church. (1,131) 1911

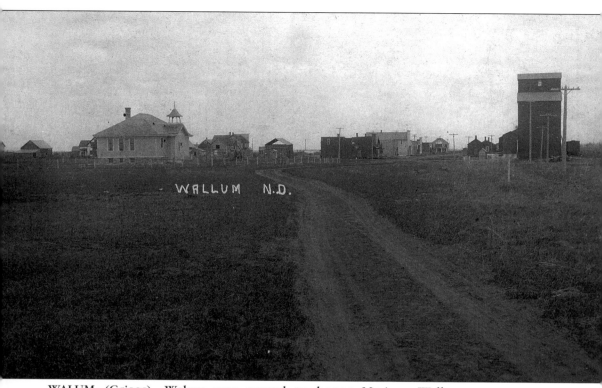

WALUM N.D.

WALUM (Griggs). Walum was named to honor Marinus Wallum, a prosperous farmer—note the different spelling. By 1905, Walum had 50 residents and several businesses were operating. In 1916, the lumberyard blew away and in 1921, the hardware store burned. The post office was closed in 1973 when the postmaster retired. Incidentally, the name is misspelled on the postcard.

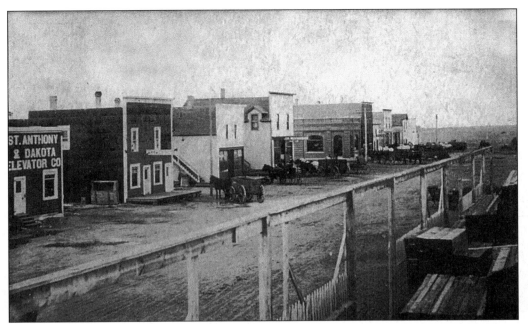

WARWICK (Benson). Warwick was plotted in 1906, and the post office opened January 26, 1907. The earliest settlers of the community, conscious of their religious needs, met for the first service in 1906. It was decided at a meeting following the service that a congregation would be organized and affiliated with the United Norwegian Church of America. (80)

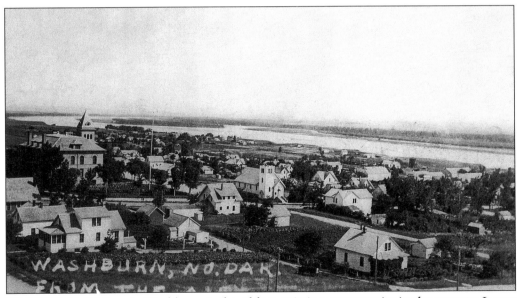

WASHBURN (McLean). Washburn is the oldest existing community in the county. It was designated as the county seat when the county was organized in 1883. Until the construction of a bridge across the Missouri River, Washburn always had a ferry to carry people across the river. (1,506)

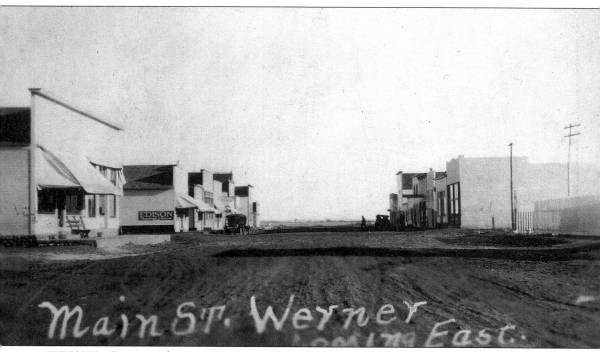

WERNER (Dunn). This town site was founded in 1914, 6 miles west of Halliday. The village incorporated in 1917, but the post office was not established until 1919. A peak population of 2,134 was reported in 1930, but the town declined after that. Arthur Kummer's service station was the last business in town, and it closed upon his death in 1970.

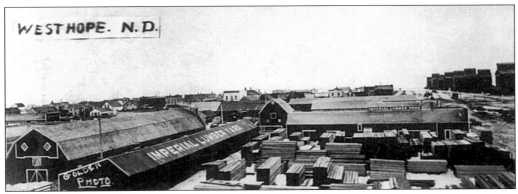

WESTHOPE (Bottineau). Westhope is known as "The City of Trees," but its name was coined from the slogan "Hope of the West"—credited to Great Northern Railroad officials to promote prosperity for the new town. The following statement appeared in the *Mouse River Standard*, "Mahra's ministrals [sic] gave the best performance ever held here. It was not only the best but also it was the first. The cast was mostly drunk. A special train will run from Rugby on the 4th of July because of the big celebration in Westhope." (578)

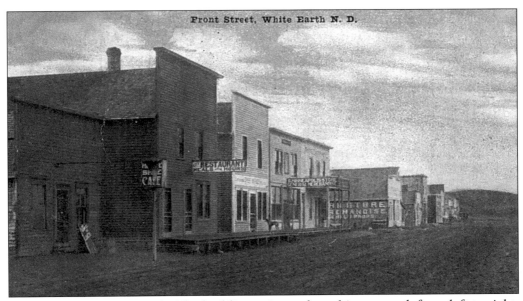

WHITE EARTH (Mountrail). The buildings pictured on this postcard, from left to right, are: the Horse Shoe Cafe (reportedly a gambling joint), the General Merchandise Store, and numerous other buildings. There were three cream-buying stations in the early 1900s. At one time, 50 large cream cans were sent out daily. (73)

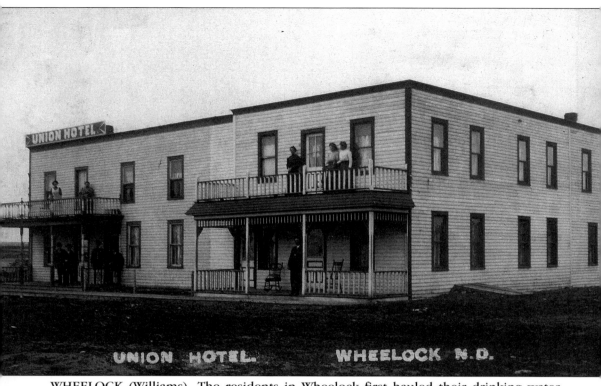

UNION HOTEL. WHEELOCK N.D.

WHEELOCK (Williams). The residents in Wheelock first hauled their drinking water from a spring nearly 3 miles west of town. In 1910, a collection was taken in the community, and a well was drilled to find good water. The same well still supplies residents today. One of the town businesses established before 1920 was the Union Hotel, owned and operated by Anna Thompson. (213)

WILD ROSE (Williams). From 1911 to 1916, grain was hauled from as far west as Grenora to the local elevators because it was at the end of the line. For some of the farmers in the western area, it was a four-day trip for each load. They would stay at Cottonwood Lake the first night, getting into Wild Rose the second day. By 1916, the Great Northern Railroad extended their branch line to Grenora. Wild Rose was now no longer the end of the line or a new boom town. (193)

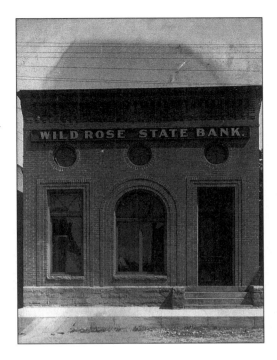

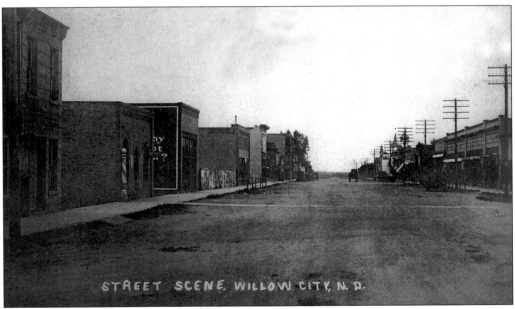

WILLOW CITY (Bottineau). This town was named in consideration of nearby Willow Creek and the abundance of willow saplings lining the banks as the creek wound its way from Willow Lake in the Turtle Mountains to its destination at the Mouse River. Notre Dame Academy, a Catholic boarding school, opened its doors in 1907. That same year, Willow City Public School held its first high school graduation for a class of one individual. (281)

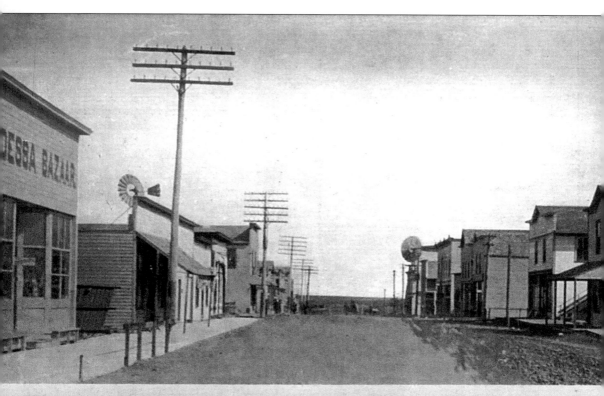

WILTON (Burleigh and McLean). In 1900, General Washburn announced that a coal expert had determined that the coal in the area was of excellent quality and in unlimited quantity. That was the beginning of the industry that was to play such an important part in Wilton's fortunes. It had electric lights before almost any other small town in the state, as the coal company strung a line into town from its plant in the mine. (728)

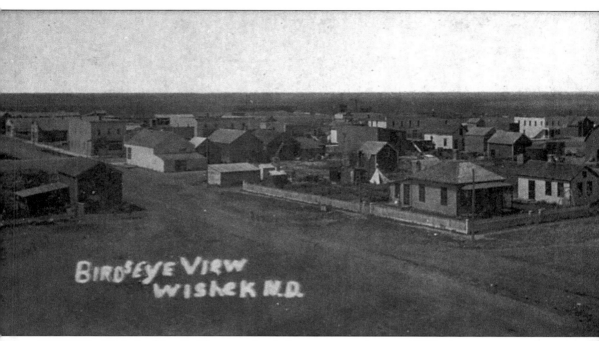

WISHEK (McIntosh). Settlers arrived here as early as 1885, but community development did not truly start until the Soo Line Railroad town site was plotted in 1898. Wishek was named for John H. Wishek Sr. (1855–1932), a rancher, politician, and promoter who lived in Ashley. In 1915, the Wishek Bottling Works was started. This was to be an up-to-date soda factory and was intended to make Wishek famous. This postcard shows the home of Mr. and Mrs. Christ Roth. (Author's Note: This home belonged to my grandparents.) (1,171)

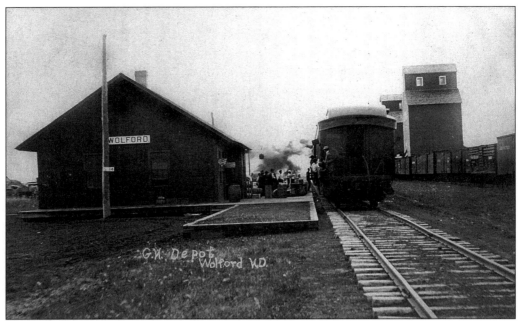

WOLFORD (Pierce). Wolford was originally called Orkney and was changed to Wolford ten years later. O.B. Berkness was the first inhabitant, arriving eight days before the Great Northern Railroad arrived. The town had its share of excitement. In 1922, the State Bank of Wolford was robbed of $3,700. Mrs. Berkness, the nervy postmistress next door to the bank, took a shot at the burglars with her .22 revolver. (56)

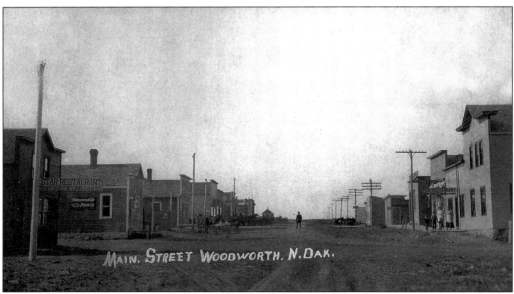

WOODWORTH (Stutsman). This Northern Pacific Railroad town site was founded in 1911, and named for J.G. Woodworth, traffic manager and vice president of the Northern Pacific Railroad. (102)

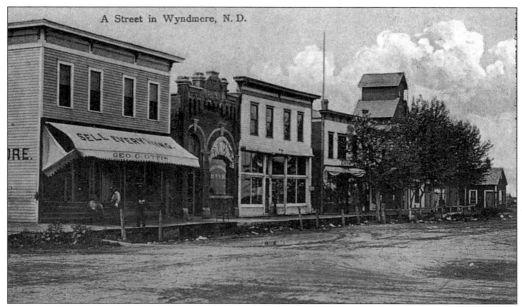

A Street in Wyndmere, N. D.

WYNDMERE (Richland). The original Wyndmere was 1 mile west of the present town site. Three miles southeast of this was the town of Moselle. The Northern Pacific Railroad arrived in the area in 1883, followed by the Soo Line Railroad in 1888. By 1889, the new town was plotted, and merging of the towns began where the two railroads crossed. The General Store awning on this postcard reads: "Sell Everything." (501)

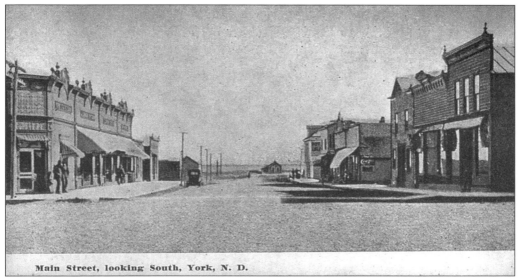

Main Street, looking South, York, N. D.

YORK (Benson). When development began here in 1886, people from the East and from Canada soon heard of the opportunities and came in boxcars, as there were no passenger trains yet. The drought of 1890 sent many families back, and by 1894, only seven families remained to continue a losing battle. In 1895, there was a bumper crop and carloads of settlers streamed back into the area. (35)

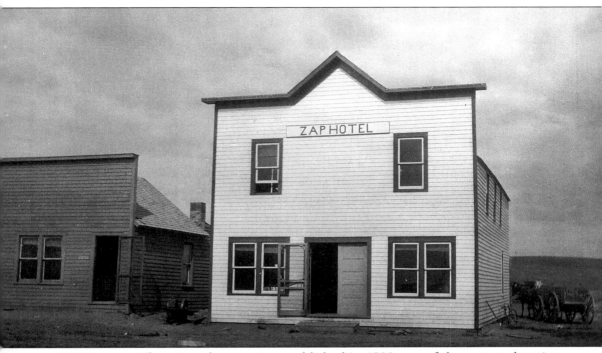

ZAP (Mercer). The original town site, established in 1890 east of the present location, was owned by the Tuttle Land Company. It will long be remembered for the "Zip To Zap" in May 1969, when thousands of college students, intent on holding a "Spring Blast," arrived in Zap. The fun turned sour at about 10 p.m. on Friday night. Many of the young people were drunk and started a bonfire in the middle of Main Street. The mayor requested that National Guard troops be brought in to help disperse the rowdy crowd. (287)

SUGGESTED READING

A Century of Area History—Pierce County and Rugby, ND. (1886–1986)
A Brief History of the County of Bottineau
A History of Dickey County, ND
A History of Emmons County
A History of Fairdale, ND by Jacob P. Westby
A History of Foster County
A History of Galchutt Community by Hans F. Syverstson
A History of Lansford, ND (1903–1953)—50th Anniversary
A History of Pembina County (1862–1967)
A History of Richland County
A History of Verona, ND
Almont Golden Jubilee (1906–1956)
Anniversary of Binford, ND
A Story of Adams County, Prairie Pioneers
Bismarck—100 Years (1872–1972)
Book of Memories, 75th Jubilee, New Leipzig, ND (1888–1980)
Bowdon Diamond Jubilee (1899–1974)
Braddock, ND (1884–1984)
Burke County and White Earth Valley
Cando and Surrounding Rural Areas—Century of Progress
Carson, ND—50th Anniversary
Centennial of Trail County (1875–1975)
Centennial Roundup: A History of Dickinson, ND
Century of Stories, Jamestown, ND
Churchs Ferry, A Complete History
Courtenay (1887–1987)
Crosby Diamond Jubilee (1904–1978)
Dauntless Dunn (1970)
Diamond Jubilee, A History of Hazelton (1978)
Diamond Jubilee, Judd, ND (1980)
Enderlin, ND—Diamond Jubilee
Fifty Years, Riverdale, ND (1947–1997)
Flasher, 75th Jubilee Book
Forest River, ND (1887–1987)
Fredonia—Diamond Jubilee (1904–1979)
Gackle Diamond Jubilee (1904–1979)
Gladstone Centennial (1892–1982)
Golden Jubilee, Makoti, ND.
Golden Jubilee, Souvenir Program and History of Sacred Heart Church
Growing with Pride: The Harvey, ND Area
Hampden Diamond Jubilee
Hannah, North Dakota—100 years
Hebron's Heritage (1885–1960)
Heritage of Lawton, North Dakota and Surrounding Areas
History of Fort Rice by Mrs. Anton Gartner
History of Rolette Count, ND, and Yarns of the Pioneers by Laura Thompson Law
Jamestown, A History (1883–1958)
Kensal Memories (1985)

Knox Area History
Kramer Tales by Charlotte Gust (1993)
Lidgerwood—Yesterday, Today and Tomorrow
Lignite, North Dakota Diamond Jubilee (1982)
Lisbon, North Dakota (1880–1980)
McLean County History (1978)
McHenry County: Its History and Its People
McIntosh County Centennial
McVille, North Dakota (1906–1981)
Medina, North Dakota—Diamond Jubilee (1889–1974)
Morton Prairie Roots (1976)
Mott, North Dakota, The First 75 Years
My Town My People—Edgeley, North Dakota
Nelson County History Book
North Dakota Place Names by Douglas A Wick
North Dakota Postcards (1900–1931) by Larry Aasen
North Dakota Towns of Extinction, manuscript by John Hensred
Oberon, North Dakota (1884–1980)
Origins of North Dakota Place Names by Mary Ann Williams (1980)
Oriska, North Dakota Centennial
Our Heritage: Leeds, York (1886–1986)
Our Heritage: Nekoma, North Dakota (1905–1980)
Park River—100 Years (1884–1984)
Pingree (1880–1980)
Pioneers and Progress, Minnewaukan Centennial (1883–1983)
Population Changes in North Dakota (1883–1993)
Prairie Notes Centennial, Taylor, North Dakota (1881–1981)
Prairie Trails to Hi-Ways
Ramsey County (1883–1983)
Ransom County History
Regent Reviews (1910–1985)
Renville County History
Richland County History
Sargent County, Its Towns, Past and Present
Sarles, North Dakota (1905–1980)
Sharon Centennial, Sharon, North Dakota
Sheridan County Heritage
Stark County Heritage
Sterling Centennial (1882–1982)
Tales of Mighty Mountrail
The Centennial Review of Dwight, North Dakota (1974)
The Edinburg Story 1882—Centennial Jubilee
The First 75 Years, Rhame, North Dakota
The History of Lisbon, North Dakota
The Luverne Ledger (1913–1917)
The Sprit Live On—Osnabrock, North Dakota (1887–1987)
The Story of Montpelier, Its First 100 Years
The Village of Starkweather
The Wonder of Williams—A History of Williams County
This Land of Mine, An Early History of Westhope, ND by Leonard and Bette Lodoen
Trail County History (1976)
Upham Diamond Jubilee (1905–1980)

Wales & Surrounding Area (1897–1997)
Walsh Heritage—Centennial Issue
Wells County, North Dakota (1884–1984)
Wilton Diamond Jubilee (1899–1974)
Zap Diamond Jubilee, Zap, North Dakota